How to Paint with
COLORED
PENCILS

How to Paint with
COLORED PENCILS

José M. Parramón

Watson-Guptill Publications/New York

Copyright © 1988 by Parramón Ediciones, S.A.
Published in 1988 in Spain by Parramón Ediciones, S.A.,
Barcelona

First published in 1989 in the United States by Watson-Guptill
Publications, a division of Billboard Publications, Inc.,
1515 Broadway, New York, New York 10036.

Library of Congress Cataloging-in-Publication Data

Parramón, José María.
 [Así se pinta con lápices de colores. English]
 How to paint with colored pencils / José M. Parramón.
 p. cm. — (Watson-Guptill artist's library)
 Translation of: Así se pinta con lápices de colores.
 ISBN 0-8230-2463-6
 1. Colored pencil drawing. I. Title. II. Series.
 NC892.P3713 1989 89-5815
 741.2`4—dc20 CIP

Distributed in the United Kingdom by Phaidon Press Ltd.,
Musterlin House, Jordan Hill Road, Oxford OX2 8DP

Manufactured in Spain by Sirven Gràfic
Legal Deposit: B. 21.059-89

1 2 3 4 5 6 7 8 9 / 93 92 91 90 89

Contents

1

Introduction

I suppose that you already know something about drawing and painting, that you have some experience with the use of lead pencils, charcoal, colored chalks, oils, watercolors, and pastels; that you know and understand all these materials; that you have painted, for example, with both cake watercolors, the liquid kinds that come in tubes and sometimes in bottles But have you painted with colored pencils? I mean, do you really know how colored pencils can be used, what their advantages are, and what effects can be achieved with them?

So that there is no misunderstanding, let me insist that colored pencils are a way of *painting*, and a medium that is still virtually *unknown*. This is basically because they are thought to be a simple and rather innocent medium, suitable only for children and third-rate amateurs. As a result, very few people appreciate their full possibilities. Yes sir, even some good artists still associate colored pencils with small tins or cardboard boxes containing twelve pencils with hard, brittle leads. "They're only good for drawing' little things line by line, color by color; you can't shade or mix your colors," or at least that's what they say.

You can put an end to the idea of innocent little pencils just by skimming through the pages of this book. You will soon see that colored pencils can do much more than just "draw little things." And as for boxes of twelve pencils, have you seen the modern metal boxes that contain assortments of sixty or seventy-two different colors? Do you know about *sticks,* those sticks of pure color that look like chalks or pastels but are made of the same material as colored pencils and come in assortments of seventy-two colors? Have you painted with one of the forty "Soft Prismalo II" colors made by Caran d'Ache? And have you used the modern kinds of paper designed for colored pencils? Canson Demi-Teintes, for example? (There's nothing like painting with "soft" colored pencils on a sheet of ochre Demi-Teinte paper, giving your work light-colored and white highlights, just as you do with pastels!)

Well, this book will tell you about all the materials and techniques that can be used when painting with colored pencils. You will find out about assortments of different colors, soft pencils, sticks and pencils that can be used as watercolors, how to use neutral or colorless pens with colored pencils, and so on. You will discover old and new techniques like *whitening* and *sgraffito*. Step-by-step explanations and practical exercises will show you all the procedures, with special emphasis on how to use colored pencils as watercolors.

This book will show you just how surprising and effective colored pencils can be.

Finally, let me say that as the author of more than thirty educational books on drawing and painting, I consider colored pencils to be an ideal way of learning how to paint. This is because they allow you to learn about painting without having to worry too much about the medium itself. You don't have to learn about how to hold and move a brush or a palette knife, how to shade or break down colors, or how to paint over previously painted areas. Since you are already used to drawing with colored pencils, painting with them doesn't present any difficulties associated with the material itself. So you can concentrate on the basic problems of mixing, combining, and above all *getting to know* your colors. I have recently done several paintings with colored pencils: a seascape, some landscapes, a few portraits—one of them of my wife—and I really had a good time doing them.

I hope this book will help you to discover the same pleasure. Now and after you read it, make sure enjoy yourself when using color pencils.

José M. Parramón

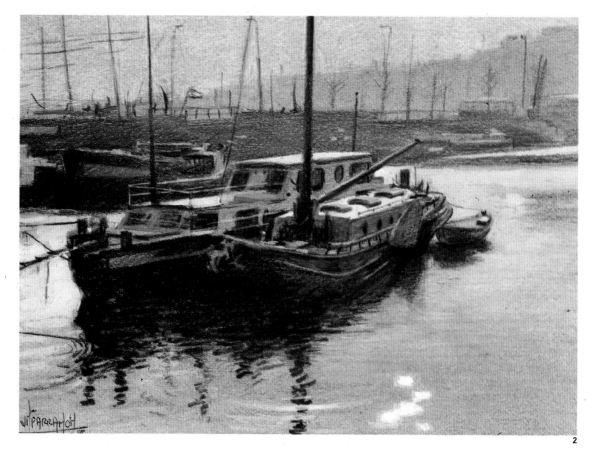

Fig. 2. With colored pencils it is possible to tackle works as complex as this seascape, which I painted a few years ago and titled *Boats in Amsterdam Harbor.* Would I have managed a richer shading with oil or watercolor?

Little artists

One day a dear friend of mine came to my studio. He is very polite, and since he did not want to bother me, he said, "If you're working, I'll go. We'll see each other another day."

"No, no, come on in! I'm painting, but we can chat while I work," I answered. I noticed a look of surprise on his face. In the studio there was no easel in use, no tubes of oil paint, no tablets of watercolor or jars of gouache to be seen anywhere. There was just a large bristol board and several colored pencils in relative disarray on the table. On the paper the first outlines of a landscape could be seen.

"But didn't you say you were painting?" asked my friend suspiciously.

"That's right. Look, I've just started: it's going to be a landscape."

"With colored pencils? You should say you were drawing. You draw with colored pencils, you don't paint. Besides, I've always thought that they were for children . . ."

Well, my friend was partly right. Col-ored pencils have always been a suitable material for schoolchildren. They draw their first scribbles with them—which are always magnificent—or amuse themselves coloring in black-and-white drawings. Although still popular, colored pencils have gradually been replaced by other media that seem to amuse children more: crayons, felt-tip pens, or even watercolors and gouache.

In one respect my friend was right, but in others, no. With colored pencils, you really *paint*. And *not* with materials suitable only for children.

You do paint; with colored pencils you can mix colors, create shades, and *think* in color, and what's all that if not painting? Of course, you can draw lines or shapes as well. So, to be more exact, let's say that with colored pencils you can paint-draw or draw-paint. And colored pencils are more than just a medium for schoolchildren. They have been used by great masters of painting and illustration.

Fig. 3. Traditionally colored pencils have been the medium children have preferred for painting their invariably splendid "works." But that is not all they are. They are quite a lot more.

3

Possibilities of colored pencils

The numerous possibilities of colored pencils have tempted painters and illustrators since the medium came into existence. Past masters such as Henri de Toulouse-Lautrec, Ramón Casas, Pablo Picasso, and Henri Matisse, as well as contemporary artists such as the English painter David Hockney, among many others, have had no problem working with this "schoolchildren's" medium. Moreover, illustrators and commercial artists achieve top-quality results with nothing more than a few pencils with colored lead—you don't need many, as we shall see. Colored pencils can be used alone or combined with other mediums and techniques, and open up a very wide range of artistic possibilities.

Colored pencil is a splendid auxiliary medium for other tasks such as making rough sketches for illustrations, posters, designs, storyboards, or other works to be completed later using other techniques. It is also excellent for trying out effects of tonal harmonization—on white or colored paper—and for doing all kinds of chromatic tests. Sketches from nature done with colored pencils can also be a valuable help in the later execution of final works.

And colored pencils have one last application—or first, depending on how you look at it—where they can be of great service. They are an ideal medium for investigating the nature of color: its mixtures, harmonies, and contrasts. Everything can be practiced with colored pencils intensively, simply, and cleanly, with no need to handle liquid paints, water, turpentine, cups, or rags. None of that. Just the colored pencils. They are completely clean. And with them you know exactly what you are doing. They are like an extension of your hand, of your fingers. You can master them without any practice and devote yourself to experimenting with color, to finding out their possibilities, directly and immediately.

4

Fig. 4. Sketches from life done with colored pencils may be of valuable help in tackling final works executed in other mediums or with colored pencils themselves.

Fig. 5. With colored pencils you can create pictures of all styles and methods, from paintings whose concept and execution are absolutely modern and daring to works with a meticulous academic finish.

5

6

Fig. 6. Classicism, modern trends, humorous drawing, illustration, rough sketches . . . and advertising material. Look at this detail of an advertising campaign for a brand of cheese done with colored pencils, a splendid piece of work in which the method chosen is halfway between the quick sketch and the latest trends in painting.

Fig. 7. What does my picture *Boats in Amsterdam Harbor* (p. 8) have to do with this illustration by the artist Horacio Helena? Nothing, except that both of them were done with colored pencils, a medium that can be adapted to all conceptions of fine and graphic arts.

7

Applications of colored pencils

The versatility of colored pencils permits a wide variety of applications in the fields of painting, illustration, and advertising. They can be used for anything ranging from quick rough sketches done in a few strokes to the most meticulously finished work, full of details and artistic touches. You can go from the purest and most rigorous academicism to humorous drawing or caricature. You can tackle what is commonly called "artistic" work or carry out a complete advertising campaign, as illustrated by the detail of one shown on the previous page. And there is a quality that colored pencil does not share with any other medium: with it you can *really* draw (make lines) and *really* paint (create stains of color).

It is quite clear that the dear friend who visited me in my studio was completely mistaken about colored pencils when he thought they were a medium suitable only for children. And so are most people.

But we shall soon see what colored pencils are capable of. To begin with, they are pretty in themselves: they have a craftsmanlike feel to them and a long tradition, and it is a pleasure to hold them in your hands. And you need hardly any training to master them completely.

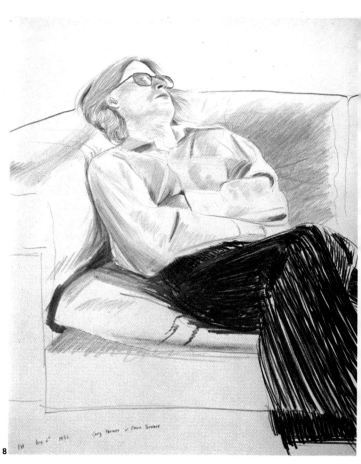

8

9

Figs. 8 to 10. Three works in colored pencil by the contemporary English painter David Hockney. The great masters of painting have always been attracted to this medium. Just look at this sample: from echoes of Toulouse-Lautrec (Fig. 8) to the delicacy of a Dufy landscape (Fig. 9) to an overtly post-modern image, the British artist gives us the measure of what can be attained with simple colored pencils.

10

Drawing and painting materials have evolved considerably, although some things have hardly changed: Vermeer's easel in the painting *The Workshop* is still used today. Nevertheless, in the seventeenth century no one would have dreamed of synthetic brushes, acrylic paint, or the felt-tip pen.

In the case of colored pencils, basic qualities and shape have remained constant. But there has been a major evolution in the range of available colors, and variants have been introduced that enrich the possibilities of the medium. Today you can find boxes of up to 72 colors, as well as watercolor pencils. Color sticks, manufactured with the same materials as the leads, are another novelty that opens up new creative possibilities.

11

—MATERIALS—

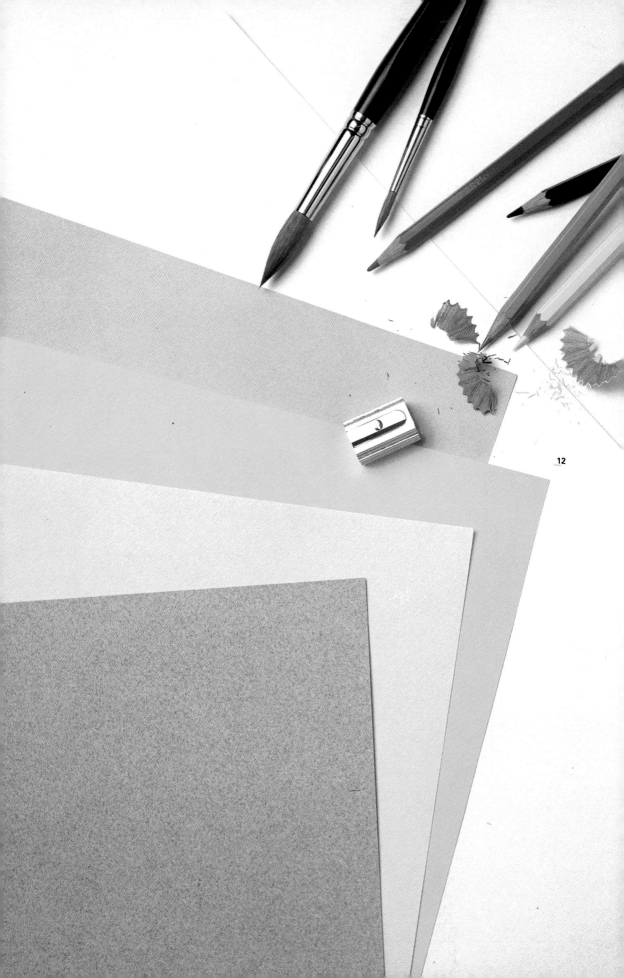

We are so used to seeing them, using them, and handling them from childhood that we never notice what beautiful and extraordinary objects colored pencils are: delicate sticks of fairly soft material, perfectly packed in a long, slender cedar-wood covering. The manufacturers present this covering painted in various colors and in two different shapes: round or hexagonal. A delightful object, colored pencil.

The stick inside, which does the painting and is commonly called the lead, is basically made of colored pigments bound with a mixture of wax and kaolin (a type of clay). The line it draws is rather soft, and unlike graphite pencils, it is not made in different degrees of hardness. There is, however, a company called Caran D'Ache, which manufactures two gradations: the normal Prismalo I and the softer Prismalo II.

Colored pencils are sold in boxes of 12, 18, 24, 36, 40, 60, and 72 colors. The boxes of 12 colors are considered best for schoolchildren. Although it is true—as you shall see—that with just the three primary colors and black you can work in a wide chromatic range, professionals work with large selections of up to 60 and 72 colors in order to paint and shade directly, thereby avoiding mixtures that deteriorate the grain of the paper and make it difficult to superimpose colors or apply successive layers.

Among the recommended brands are the English Rexel Cumberland Derwent, with a selection of up to 72 colors; the German Faber-Castell Spectracolor, 60 colors; the Swiss Caran D'Ache, 40 colors; the German Staedtler, Schwan-Stabilo, and Lyra-Rembrandt; and the American brands Berol Prismacolor, 72 colors, and Mongol. You can be quite sure that the manufacturers mentioned here, with their large selections and many years on the market, supply high-quality colored pencils, but in the end, choosing one over another comes down to a question of each artist's personal preference.

Many colored pencils on the market today are water-soluble and can be used for watercolor painting (I will soon be talking about them); normal colored pencils are described as *water-resistant*. In any case, if you want to be certain that the colored pencils you buy can be used for watercolor painting, read package labels carefully. Caran D'Ache, Schwan-Stabilo, Faber-Castell, and Rexel Cumberland are a few of the manufacturers that produce them.

All the manufacturers just mentioned supply loose colored pencils as well as sets, so that you can restock the ones you use up.

There are also color leads, between 0.5 and 2.0 mm thick with a range of up to 17 colors, that are designed to be used in mechanical pencils of the same caliber. Mechanical pencils are ideal (especially the 0.5 mm ones) for technical drawings done with a ruler and high-precision measurements. I will discuss all-lead sticks in a moment.

Fig. 12. Draw-painting with colored pencils is an artistic activity that can yield extraordinary results with limited means. Shown here are pencils in the three primary colors and black, with which all colors can be mixed (as you shall soon see), an ordinary pencil-sharpener, colored paper, and brushes for painting with watercolor pencils.

Brands and selections

Watercolor pencils and "all-lead" sticks are the two most notable variants of colored pencils (the former have been around for several decades). Watercolor pencils have a twofold function. On the one hand, they can do the work they were made to do: to draw lines like any other pencil. But if water is added to the lines with a brush, they melt into one another and look like a stain made with watercolors. Watercolor painting is the second function of watercolor pencils.

Some professionals think that this technique is of no interest. They reckon that it is better to work directly with watercolors to get painted effects. Nevertheless, it is not quite the same and, in some cases, the colored pencils even have advantages. What is sure is that this procedure has not been sufficiently exploited and still has interesting possibilities to be discovered.

Figs. 13 to 16. On the right (Fig. 13) you can see a box of Caran D'Ache with 40 watercolor pencils in the Prismalo I line, the normal hardness color pencils, not to be confused with Prismalo II, which are softer. Rexel Cumberland Derwent offers the widest range currently available on the market: 72 watercolors (Fig. 14). The North American brand Mongol has created a special case that makes it easier to take out the pencils than from a flat box (Fig. 15). Finally, Fig. 16 shows a case of 60 colored pencils (the water-resistant type) from the well-known Faber-Castell.

Fig. 17. At the bottom of the page you can see some colored pencils from the case in Fig. 16, a non-watercolor range from Faber-Castell that is wide enough to obtain the finest chromatic shades.

15

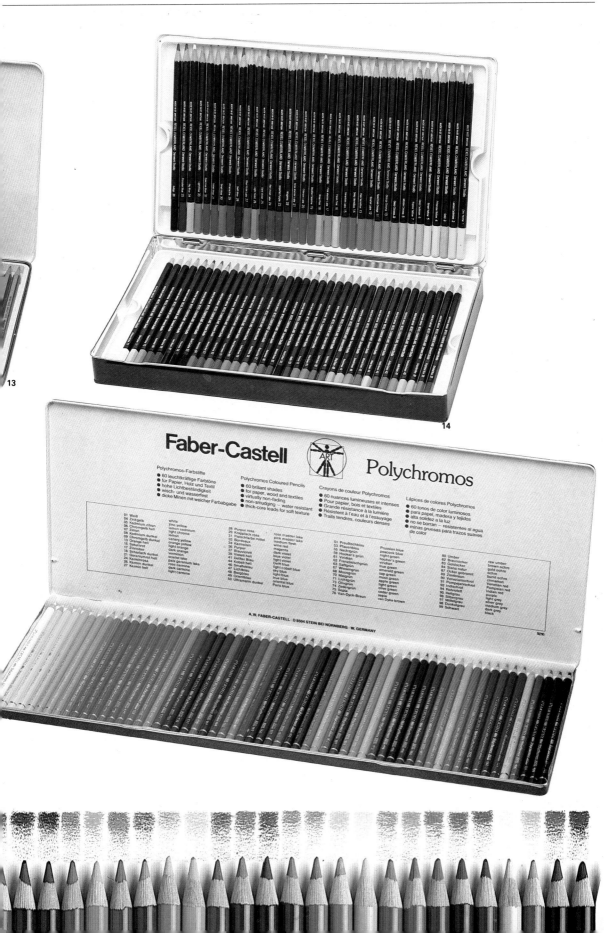

13

14

Faber-Castell · Polychromos

Polychromos-Farbstifte
- 60 leuchtkräftige Farbtöne
- für Papier, Holz und Textil
- hohe Lichtbeständigkeit
- wisch- und wasserfest
- dicke Minen mit weicher Farbabgabe

Polychromos Coloured Pencils
- 60 brilliant shades
- for paper, wood and textiles
- virtually non-fading
- non-smudging — water resistant
- thick-core leads for soft texture

Crayons de couleur Polychromos
- 60 nuances lumineuses et intenses
- Pour papier, bois et textiles
- Grande résistance à la lumière
- Résistent à l'eau et à l'essuyage
- Traits tendres, couleurs denses

Lápices de colores Polychromos
- 60 tonos de color luminosos
- para papel, madera y tejidos
- alta solidez a la luz
- no se borran — resistentes al agua
- minas pruesas para trazos suaves de color

01 Weiß	white	28 Purpur rosa	rose madder lake	51 Preußischblau	Prussian blue	80 Umber	raw umber
04 Zinkgelb	zinc yellow	29 Krapplack rosa	pink madder lake	53 Pfauenblau	peacock blue	82 Braunocker	brown ochre
06 Kadmium zitron	lemon cadmium	31 Fleischfarbe mittel	medium flesh	55 Nachtgrün	night green	83 Goldocker	gold ochre
08 Chromgelb hell	light chrome	33 Bordeaux	wine red	56 Hooker's grün	hooker's green	84 Siena natur	ochre
05 Zitron	lemon	34 Karmesin	magenta	61 Viridian	viridian	87 Ocker gebrannt	burnt ochre
08 Kadmium dunkel	canary yellow	37 Purpur	dark violet	62 Französischgrün	true green	89 Zimtbraun	cinnamon
08 Chromgelb dunkel	orange yellow	37 Blauviolett	blue violet	63 Saftgrün	emerald green	90 Venezianischrot	Venetian red
13 Orange hell	light orange	39 Violett hell	light violet	67 Wiesengrün	sap green	91 Pompejanischrot	Pompeian red
15 Saturnrot	dark orange	41 Delfter Blau	light cobalt blue	68 Moosgrün	moss green	92 Indischrot	Indian red
17 Zinnober	vermillion	44 Kobalt hell	sky blue	70 Maigrün	apple green	94 Rotviolett	purple
21 Schalach dunkel	scarlet lake	46 Smalteblau	light blue	71 Lichtgrün	light green	95 Heligrau	light grey
21 Geraniumrot hell	pale geranium lake	47 Lichtblau	true blue	73 Olivgrün	olive green	96 Silbergrau	silver grey
26 Karminrosa	rose carmine	48 Bergblau	oriental blue	74 Zedergrün	cedar green	97 Mittelgrau	medium grey
26 Karmin dunkel	dark carmine	49 Orientblau	Paris blue	75 Sepia	sepia	98 Dunkelgrau	dark grey
27 Karmin hell	light carmine	50 Ultramarin dunkel		76 Van-Dyck-Braun	van Dyke brown	99 Schwarz	black

A.W. FABER-CASTELL · D 8504 STEIN BEI NÜRNBERG · W. GERMANY

9216

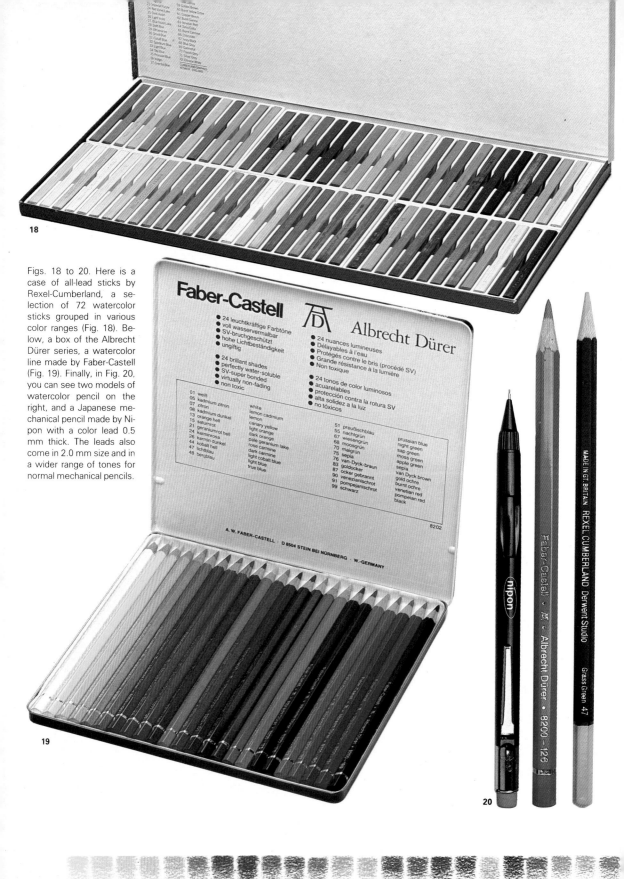

18

Figs. 18 to 20. Here is a case of all-lead sticks by Rexel-Cumberland, a selection of 72 watercolor sticks grouped in various color ranges (Fig. 18). Below, a box of the Albrecht Dürer series, a watercolor line made by Faber-Castell (Fig. 19). Finally, in Fig. 20, you can see two models of watercolor pencil on the right, and a Japanese mechanical pencil made by Nipon with a color lead 0.5 mm thick. The leads also come in 2.0 mm size and in a wider range of tones for normal mechanical pencils.

Faber-Castell — Albrecht Dürer

- 24 leuchtkräftige Farbtöne
- voll wasservermalbar
- SV-bruchgeschützt
- hohe Lichtbeständigkeit
- ungiftig

- 24 brillant shades
- perfectly water-soluble
- SV-super bonded
- virtually non-fading
- non toxic

- 24 nuances lumineuses
- Délayables à l'eau
- Protégés contre le bris (procédé SV)
- Grande résistance à la lumière
- Non toxique

- 24 tonos de color luminosos
- acuarelables
- protección contra la rotura SV
- alta solidez a la luz
- no tóxicos

01 weiß	white	51 preußischblau	prussian blue
05 kadmium zitron	lemon cadmium	55 nachtgrün	night green
07 zitron	lemon	67 wiesengrün	sap green
08 kadmium dunkel	canary yellow	68 moosgrün	moss green
13 orange hell	light orange	70 maigrün	apple green
15 saturnrot	dark orange	75 sepia	sepia
21 geraniumrot hell	pale geranium lake	76 van-Dyck-braun	Van Dyck brown
24 karminrosa	rose carmine	83 goldocker	gold ochre
26 karmin dunkel	dark carmine	87 ocker gebrannt	burnt ochre
44 kobalt hell	light cobalt blue	90 venezianischrot	venetian red
47 lichtblau	light blue	91 pompejanischrot	pompeian red
48 bergblau	true blue	99 schwarz	black

8202

A. W. FABER-CASTELL · D 8504 STEIN BEI NÜRNBERG · W-GERMANY

19

20

Sticks

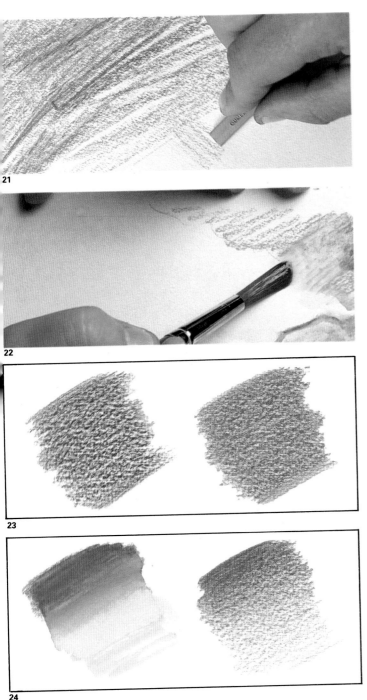

The "all-lead" sticks consist of small bars made of the same material as the colored pencils. They are 8.0 mm wide and 4.7 inches (12 cm) long and are covered with lacquer to prevent the fingers from getting stained with pigment. The most interesting selection is made by Rexel-Cumberland Derwent, with 72 colors; these are like the pencils, but with the special feature that they also come in loose groups of 12 corresponding to certain ranges: shadow colors, pastel colors, intense colors, and so on.

As the sticks are so broad, you can use them for painting backgrounds and large flat areas of color as though they were pastels. They are also useful for creating broad lines.

Using watercolor pencils and colored sticks is technically as simple as using a normal pencil. Colored sticks are hard media that the fingers can master totally and with almost no problems. In any case, the application of water when using watercolor pencils is what could cause greater difficulty. This will be discussed shortly.

Fig. 21. The all-lead sticks are especially suitable for covering backgrounds with color, as they are so broad, although they can also draw fine lines if the corners are used.

Fig. 22. Watercolor painting with pencils has no great secrets. First you draw normally and then apply water with the brush, which melts the pencil lines.

Figs. 23 and 24. In the stains done with colored pencils without watercoloring, the lines and grain of the paper can be seen (Fig. 23). When water is applied (Fig. 24), the lines blend and take on more or less the appearance of a watercolor stain. Compare the sepia stain with the others.

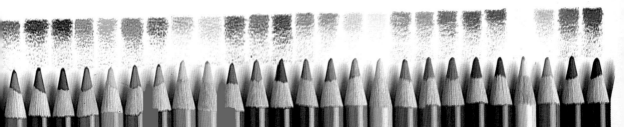

Paper

Theoretically, with colored pencils it is possible to paint on *any* paper provided that it is neither too glossy nor too rough—anything from ordinary-quality drawing paper to wrapping paper. Nevertheless, professionals generally use high-quality rag papers with which the manufacturer has taken special care and has borne in mind the needs of the user.

To begin with, there are three distinct classes of paper, grouped according to the texture and color of the surface:

1. Fine-grain papers.
2. Medium-grain papers.
3. Colored papers.

I have deliberately left out glossy papers, which have a very smooth surface to which colored pencil has trouble "clinging"; and rough papers, whose surface is so bumpy that the pencil moves over it with difficulty and results in broken lines (of course, the artist may choose these papers when aiming for specific effects of finish and texture).

Colored papers are worthy of special mention, especially Canson's Mi-Teintes, which comes in a wide range of tones suitable for painting with colored pencils, as you can see at the bottom of these pages.

It should be mentioned at this point that quality drawing papers have a dif-

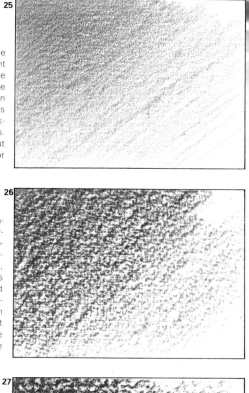

25

Fig. 25. The effect of the pencil on the different types of paper is not the same. Here you can see the result of drawing on fine-grain paper, perhaps the most suitable for working with colored pencils. The result is a soft but shaded quality, ideal for any work.

26

Fig. 26. Medium-grain paper. As you can see, the irregular surface of the support is much more noticeable. It is also interesting, especially for large formats and works where the artist is trying to achieve a certain vigor in the textures. In every case, observe that besides the color of the pencil, the white of the paper is also present.

27

Fig. 27. Rough-grain paper. The characteristics of medium-grain paper are accentuated here. Everything is more vigorous, more "expressionistic." This paper can be used with colored pencils in a large format and a style aimed at making a strong impact. You will have to be very careful about the lead, which is used up very quickly.

Fig. 28. Here is a sample of medium-grain colored papers from the French company Canson, highly suited to working with pencils. As you can see, they cover a wide range of tones from intense to very pale. The pale ones are the best for painting with colored pencils.

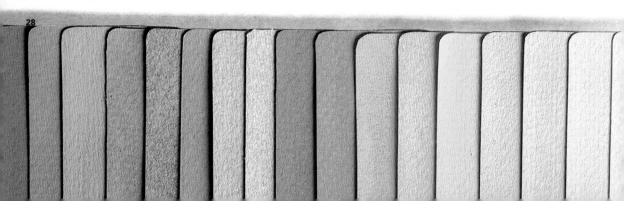

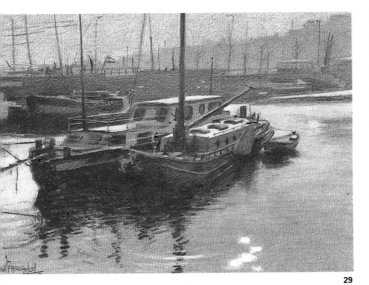

29

ferent texture or roughness on each side, but they can be used on either, with the advantage that the artist can choose the most suitable one for the work at hand.

Finally, listed in the box below are the best-known and most highly recommended brands of quality paper for drawing, which are generally found in all countries.

MANUFACTURERS OF QUALITY DRAWING PAPERS	
Arches	France
Canson	France
Canson Mi-Teintes	France
Schoeller Parole ...	Germany
Schoeller Turm	Germany
Fabriano	Italy
Whatman	Great Britain
Winsor & Newton	Great Britain
Grumbacher ...	United States
Guarro	Spain

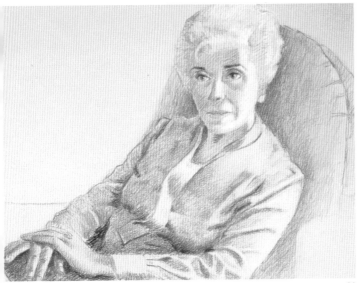

30

Figs. 29 and 30. Above is a seascape on gray paper Below, a portrait on beige paper. The tones of the papers add an extra color to both works that contributes to creating the required atmosphere according to the artist's wishes and the character of the work. In these examples the colored papers establish a cooler general tone for the seascape and a warm one for the portrait.

Watercolor pencils

Let us start with the most complicated part, the technique of watercolor pencils. Basically you need a box of pencils and clean tap water; sable-hair brushes, a sponge, and blotting paper—rolls of blotting paper, paper towels, or tissues (see Fig. 31.)

The brushes can also be made of mongoose hair, ox hair, or synthetic hair, but sable-hair brushes are recommended for their superior quality, which may be summed up as follows: they are spongy, and they have a great capacity for holding large quantities of water and color, for bending at the lightest pressure of the hand, for fanning out, and for painting with broad strokes and returning to their original position and always maintaining a perfect point. In Figs. 35, 36, and 37 you can see how it works in practice. The results can be very interesting: you get a

Fig. 31. Here is all you need for watercolor painting with colored pencils: paper towels, water, and brushes.

31

32

33

34

35

Figs. 32 to 34. Working with watercolor pencils you can lift out whites just as in watercolor painting. First, with water and brush, wet the area where you want to establish white (Fig. 32). As you apply the water, rub with the brush to loosen the particles of color. Then, with a piece of paper towel, mop up the water, which will lift the loose pigment particles (Fig. 33). The operation is repeated two or three times until you obtain an acceptable white that can

be accentuated with the aid of bleach diluted with water; use a synthetic-hair brush for this part (Fig. 34).

Fig. 35. The basic technique of watercolor pencils can be seen here. It is a question of blending the pencil lines by applying water with the brush. Nevertheless, the lines can still be seen underneath, which gives the final result a particular character that regular watercolor paint does not have.

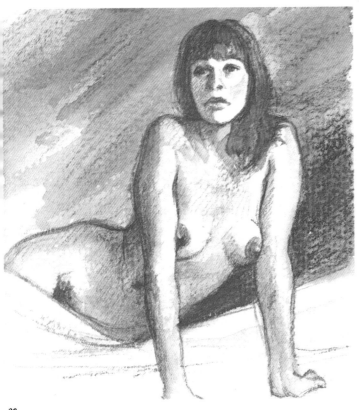

36

work that looks like watercolor, but in which the lines of the drawing can also be seen. The work is a drawing-painting or a painting-drawing, fresh and spontaneous, something valid in itself, but one that can also be useful as a first sketch for later works.

As in watercolor, you can lift color to obtain whites by applying water and using blotting paper. This technique is often indispensable for obtaining certain final effects (Figs. 32, 33, and 34). You can work in monochrome or full color; both approaches offer artistic possibilities. A monochrome—or bichrome— approach is especially useful for producing tonal experiments for works to be executed later in full color. And the monochrome study has another use. It is a wonderful practical exercise for learning the technique of watercolor pencils without worrying about problems of color.

We will eventually get into the subject in depth and will do an exercise with watercolor pencils. Get your materials ready.

Figs. 36 and 37. Above, a work in monochrome done with watercolor pencils. Below, the same model in full color, something like a gouache in the first case and a watercolor in the second, but with a personality of its own. The pencil lines can still be seen, creating a fresh, very interesting quality that is somewhere between drawing and painting.

37

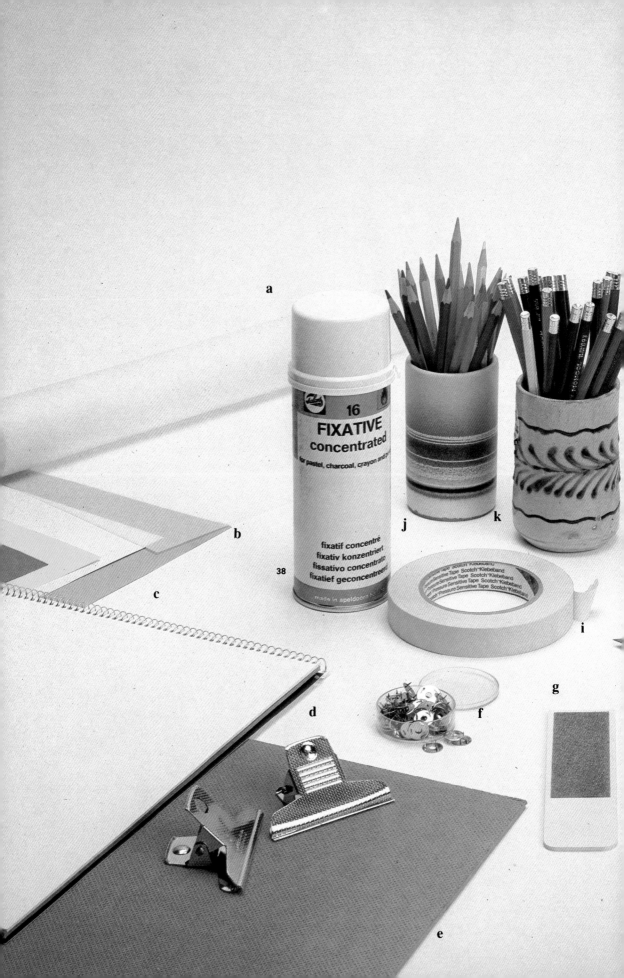

Fig. 38. In addition to the basic materials required, all artistic techniques call for additional equipment that is indispensable if you want to work comfortably. The same can be said of colored pencils. For instance:

White and colored bristol boards (b), absolutely essential for working.

Notebook for sketches—or final works—that will be especially useful when working outdoors (c).

A Masonite board (e) that can be used as a support for the paper either in the studio or outdoors; clips to hold the paper to the board (d); and drawing pins or tacks (f), which you can use for the same purpose, or for putting your drawings up on the wall.

Adhesive tape (i) to mask margins around the picture when painting with watercolor pencils and for other tasks, such as affixing tracing paper (a) on an image to make a copy.

Fixative (j). There are several types; today the most practical kind is the aerosol spray, which spreads the fixative particles very evenly.

Jars for holding pencils (k, l), which make the pencils much easier to reach than when they are kept in their boxes.

Water and a container for it (m), essential if you are working with watercolor pencils.

Sandpaper (g) for sharpening pencils when you want to draw very slender lines. The classic graphite pencil (o), sometimes useful for certain small finishing touches. Beside it is a holder for using up the ends of colored pencils.

A felt-tip pen (p), which, in certain techniques, can be combined with colored pencil (see page 39).

Eraser (r), not much use when working with colored pencils, but it can be used in certain cases.

The classic sharpener (q) and a scratch knife (n) for the scraping technique (see page 36).

A cutter (h) for cutting paper and sharpening the pencils if preferred to a regular sharpener.

Stumps (s), almost indispensable in graphite pencil drawing but scarcely ever used with colored pencils. And a folder for storing the drawings and especially for carrying them from one place to another (t).

m

o

n

p

r

q

s t

39

Fig. 39. Finally, here is a vital element for the studio: a portfolio for keeping large-format works, folders, paper, and so on.

The post-impressionist painter Vincent van Gogh wrote: "There are laws of proportion, of light and shade and perspective which we must know in order to be able to paint. If we do not possess this knowledge, the struggle is always barren and we will never manage to give birth." Here, the Dutch genius was referring to the basic principles of painting and drawing. But the same can be said if we are referring to the practice and the technique of our trade. There are also laws, and there is also one way—and no other—of doing things, "manual" work, a mastery of the tools that you must achieve if the struggle is not to be barren. This is perhaps the humblest aspect of the artist's work. But indispensable.

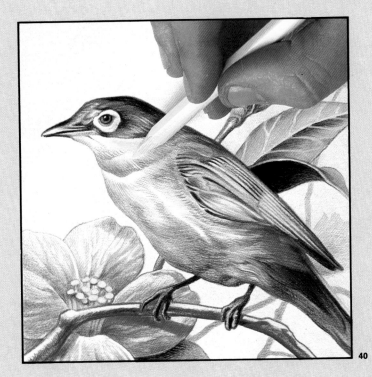

40

— TECHNIQUES —

Additional tools and materials

The grain of the paper, the soft or semi-soft point of the pencil: These are the two primordial elements at your disposal when drawing with colored pencils. And the technique of this medium involves knowing how best to bring them together.

Let us suppose that you use a yellow pencil. The fine- or medium-grain paper is not completely smooth. It has a few minuscule bumps over which the lead will run. If you press the pencil gently on the paper, the yellow pigment and the waxes will stick to these bumps, but not to all of them. Some will remain free.

This principle is basic: let the colors mix. If you apply a new layer in the same area—this time with red—you will stain new protuberances that had previously remained white. The eye—by means of what is known as *optical mix*—will see a stain of orange color. Even if you did not apply the second color, you should still have a mixture: the tone you have put on and the white of the paper.

First principle, therefore: in order to paint a tone or mix colors, the pencil must run smoothly over the support. If you want a color to paint cleanly and intensely, you must apply more pressure. Then the pigments and waxes of the lead will not remain hollow; they will cover everything.

The pressure of the pencil, then, is important. The pencil's sharpness is also important. The pencil must always have a good point; make sure it's not blunt, which happens fast with colored pencils. The pencils have to be sharpened frequently. To cover large and medium-size areas, the lead should be rather rounded and not too sharp (as in Figs. 41 and 42). For small touches of detail, the lead should be really sharp.

Holding the pencil properly is equally important. But there are no secrets. For drawing, the pencil is held as it is for writing, just a little higher. It can also be held with the stem in the hand, as you can see in Fig. 44. In any case, do not worry too much. Take the pencil between your fingers in the way that is most comfortable for you, provided that you do not do so in a really strange or twisted way. The most important thing is that you can run your hand freely and without fear.

An eraser is hardly ever used when working with colored pencils. In areas with heavy color applications the eraser is not only useless but actually harmful. If you rub with it, you will spread the wax of the lead and make everything dirty beyond any possibility of repair. Nor should you think of removing whites with an eraser, as is done in drawing with graphite pencil. However, an eraser can be used over soft initial lines or to reduce tones that have been obtained with hardly any pressure on the pencil. Use it in these and no other cases.

Try to be comfortable when you work. You do not need a large space, but you do need to be comfortable. A sloping board is ideal. You can also work on a horizontal table if the drawing is small. The light, as you know, must always come in from the left, except if you are lefthanded, of course. How about starting to practice a little?

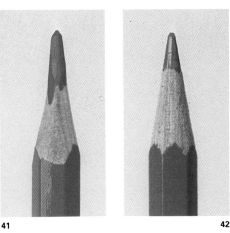

41 **42**

Figs. 41 and 42. The point of the pencil is always important when it comes to working, far more so than it might seem at the beginning. Many amateurs get unsatisfactory results simply because of a persistent bad habit of working with pencils without proper points. There are two ways of getting a point on the pencil: with a cutter (Fig. 41) and with the classic sharpener (Fig. 42). The sharpener is better for small-format works. It gives you a sufficiently sharp point. The point you get with a cutter, however, has an advantage when you are working on larger formats because it can uncover a greater length of lead, which, given the speed with which colored pencils are used up, means that you can work for longer periods without having to sharpen them.

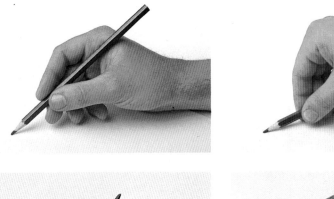

43 **44**

Figs. 43 and 44. The pencil can be held as it is for writing (Fig. 43) but slightly higher up, or sideways (Fig. 44). The second way is used particularly for painting on vertical or sloping surfaces and when you are drawing fairly long lines that require agility and speed.

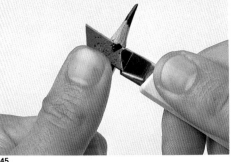

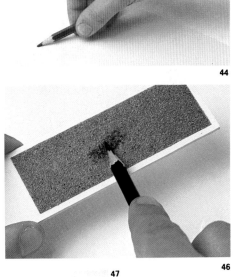

45 **46**

47

Figs. 45 and 46. Here you can see exactly how to get a point on the pencil with a cutter (Fig. 45). The thumb pushes the blade over the wood, thus allowing greater control over the action. If you want a sharp point, you have to use some kind of scraper (Fig. 46). The point is rubbed on it horizontally while you turn the pencil so that the sandpaper acts on the whole perimeter of the lead.

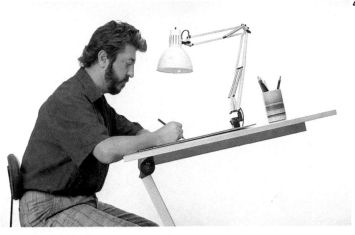

Fig. 47. This is the ideal position for working. A sloping board, light from the left and a distance from the paper, neither too close nor too far away.

How to draw-paint with colored pencils

Fig. 48. If you have a box of 40 or 60 colored pencils, you obviously will not use them all in one work. Generally you use certain well-defined ranges—each artist has his own—and there are many colors that are used only in exceptional cases. The best way is to keep the seven or ten pencils you use most often in your left hand while you draw with your right. This way you avoid having to look for the colored pencils in the box every time.

48

Fig. 49. Another system that will spare you the continual search for pencils in the box consists of having them at hand in a jar. The most frequently used pencils are stored there, and it is much easier to take them out of this container than out of the case. If you want to perfect the system, you can have a jar for warm colors and another for cool ones. And you could even have another one for the range of dull colors. This would be order of an exceptional kind, quite unusual among artists.

49

Fig. 50. Achieving gradations with colored pencils is not as difficult as many amateurs think. You begin by drawing a zigzag with the pencil from top to bottom, gradually reducing the pressure of the lead on the paper (a). Don't be afraid. Press hard at the beginning, then more gently little by little until the end, when you are scarcely brushing the surface of the support. The grading is done. In some areas there will still be irregular tones or lighter ones than you wanted. Retouch these with the utmost care; press just enough according to whether you are above or below the grading (b). The final result should look like what you see in the last illustration (c).

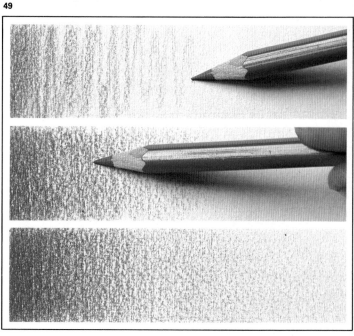

50

51

52

53

54

55

Fig. 51. When you work with colored pencils, you always have to bear in mind what was pointed out on page 22. The waxes and pigments do not cover all the tiny protuberances on the paper. Some stay white. Therefore, it is like mixing white with the colors you use. And so, if you want to obtain a pink grading, for example, you must use a red. The paper will serve as the white color that reduces the red tone.

Fig. 52. To obtain the stain in the warm tones that you see here, you should use eight colors from the same range: yellows, ochres, and earth tones or browns. You should apply them all successively from the lightest to the darkest. Blend the areas where the colors overlap to achieve a soft tonal continuity. The result is very good, as you can see: pictoric and pleasant. But, as you will observe in the next illustration, you can do it differently.

Fig. 53. Here you have a stain almost exactly like the one before, except that you work with only three colors, the three primaries: yellow, blue, and magenta. To obtain the same shades as with eight colors, you will have to mix the three colors in different proportions. Note: with the three primary colors alone, you can make any color in nature. But you don't have to do that much, just practice the mixes regularly and with the enthusiasm of a researcher. You will see the results immediately.

Fig. 54. With colored pencils, the sequence in which you apply one color over another affects the results. Look at this example, where you mix yellow and blue. In the first case you put the blue first and then superimpose the yellow. The result: light green. In the second case you reverse the order. Result: dark green. Why does this happen? Because the dark colors cover the light ones more than the other way around.

Fig. 55. Look at the blue stain here on the left. As you can see, in the center there is an area that looks different from the rest. It is lighter and it has a pastel appearance with more blended lines, as well as a slight hint of the grain of the paper. This is another effect you can achieve with colored pencils; it is obtained by applying white pencil on the area of the work you want to look like pastel. The white lightens the tones, blends the lines, and suppresses the characteristic grain of the paper.

Always paint from less to more

Yes, *from less to more:* that is the way to work with colored pencils. First apply the less intense tones and then gradually superimpose the more intense ones.

Look at the example of the coffee cup in the step-by-step images. I began with a gentle toning in the whole drawing. Then I gradually added darker shades in successive layers. In the last phase, areas that are almost black and fine details can be seen. This is the way to paint with colored pencils: by building the values and the contrasts.

It would be impossible to work the other way around. The lighter colors of the pencils do not cover the darker ones. And so, let me make a suggestion that I consider fundamental: always begin with caution, toning gently at the beginning, even underpainting. That is better than overpainting. If you overpaint, there is no way back. So little by little, from *less to more.*

Techniques for painting with colored pencils

By techniques I mean procedures, or ways of doing. Let me be specific. I will give you five possibilities:
— line technique,
— tonal technique,
— grattage (or scraping) technique,
— sgraffito technique and
— whitening technique.
The first two procedures, line and tonal, are the most frequently used.

Line technique
Observe the landscape on the following page. It is a perfect example of line technique. What it is about is quite obvious. The values, the shades, the contrasts are achieved by means of the superimposition of crossed lines that form wefts. In certain areas, the ones with the more intense tones, there are more layers of superimposed lines, and the weft is more dense. In the lighter ones, the opposite happens. And I have always worked from less to more.

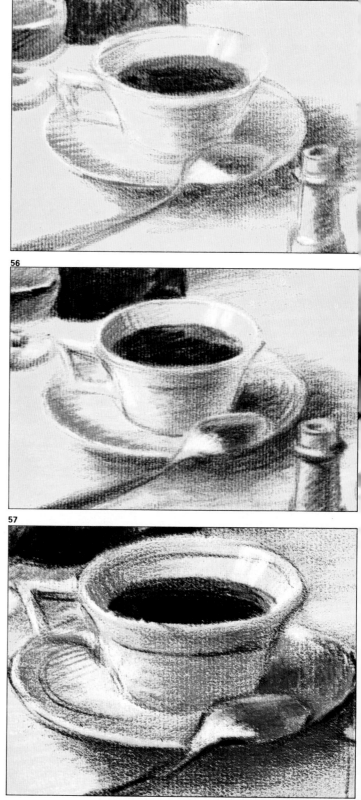

56

57

58

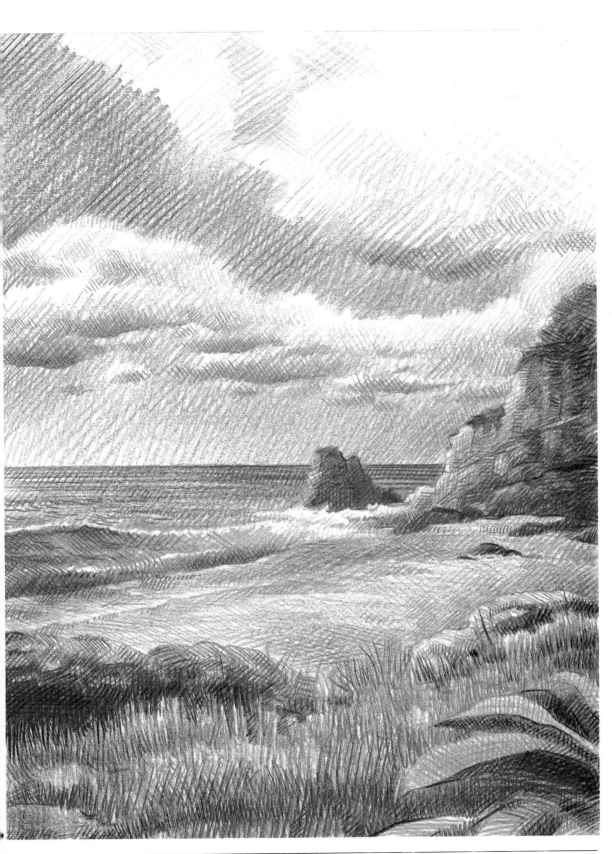

Techniques for painting with colored pencils

Tonal technique

Here is an example of this technique in Fig. 61. This is the basic procedure. Always working from less to more, volumes are modeled and color values and shades are established with the pencil. The stain and the visible line can be combined (Fig. 60). I say "visible" because the stains, in pencil, are also created with lines, which are so close together that the whole gives the appearance of continuous tones. In the example shown here I worked very gently, respecting the grain of the paper. The result is smooth and harmonious.

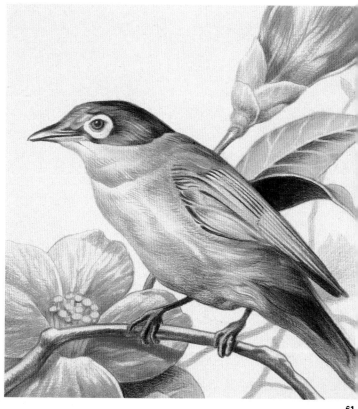

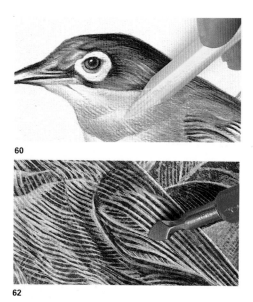

60

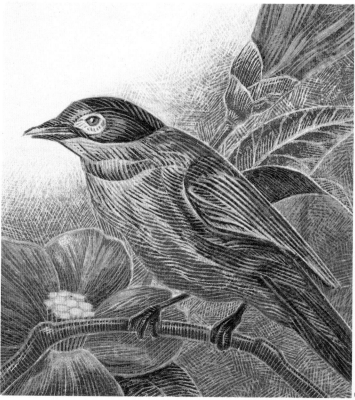

61

62

Grattage (or scraping) technique

First you paint the subject normally, using the tonal technique, with light colors. Next—be careful, now—you apply a new layer of color on top, the same as before, but in a darker value. Then take a scratch knife. With this instrument you make a "drawing" on top of the image you have just painted (Fig. 62). With each line you draw, you take away the wax of the second color so that the pigment of the first layer is visible beneath.

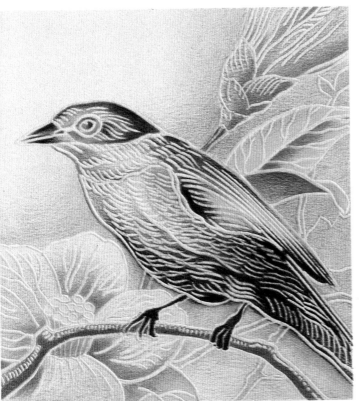

64

Sgraffito technique

Look at the example on the left. On a fine pulp paper you make a line drawing of the subject with graphite pencil. Then you affix this pulp paper to bristol board. By means of a needle with a blunt point or a ballpoint pen, you go over the pencil lines, making indentations in the drawing paper underneath (Fig. 65). When you remove the pulp paper, you will have obtained a kind of incised drawing of the bird. Now you paint on the bristol board with the colored pencils using the tonal technique.

65

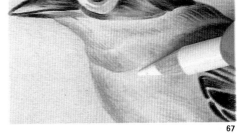

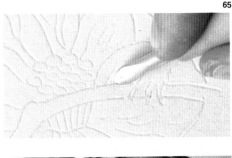

67

Whitening technique

What difference can you see between this bird and the one at the top of the previous page? The colors of this one look more blended, creamier. It looks like a pastel painting. How has this effect been achieved? It is really very simple: you apply white pencil over a work that has been previously done with the normal tonal technique (Fig. 67). With the white pencil, lines are blended, the effects of the grain of the paper disappear, and the colors become lighter. Observe the result in Fig. 66.

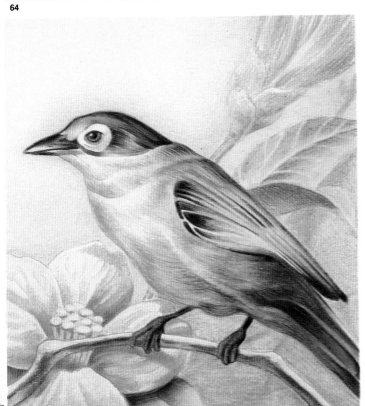

6

Illustration techniques

Colored pencils are often used in illustration, whether alone or combined with other techniques. Well-known artists have been able to take advantage of the ductility of this medium to do work of splendid quality.

Although it is possible to use colored pencils alone, it is more common to apply them as a complementary technique to value drawings done in the flat colors of watercolor.

On this page you can see the process generally followed by the illustrator María Rius. The background has been done with an airbrush, leaving the figure of the girl and the birds in white. These two motifs have been painted afterward with watercolor. Finally, the colored pencil comes into play. It has been used to darken certain areas of the drawing, outlines have been retouched (in the hair, for example), and overall values have been established in the drawing.

Most art illustrators use the same method. Watercolor is used to create the flat drawing, and the pencils, rotated gently to produce different intensities of line, are used to give the illustration volume and light, as well as for certain outlines that lend vigor and definition to the finished work.

68

69

Figs. 68 to 70. Colored pencils are an auxiliary medium in common use among illustrators. Look at the process the famous illustrator María Rius follows. First she has done the background with an airbrush, leaving the central figure and the birds white (Fig. 68). Then she has painted these motifs with almost flat watercolor (Fig. 69). Finally, she has used colored pencils to create values, outline, and put in all the final details of the work.

70

Colored pencils, airbrush, and felt-tip pens

Colored pencils also have a similar application to the one you saw on the previous page when used with the airbrush as the basis of the work. A few final touches with the pencils can be decisive.

A technique that may be new to you is to use a neutral or colorless felt-tip pen with watercolor pencils. Try it, because your own practice is what will allow you to deduce how and when to apply the colorless pen. Colorless felt-tip pens are called "blenders" by the firms that make them.

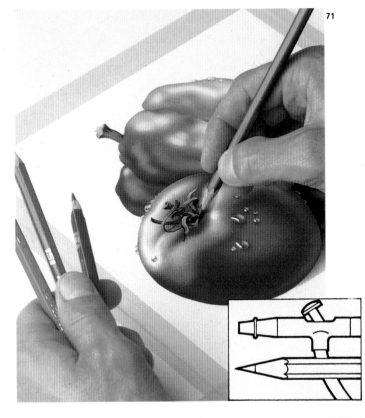

Fig. 71. Colored pencils are also a valuable help when you are filling in the final details of an illustration done with an airbrush; they are especially useful for emphasizing outlines and retouching tones in small areas where you need to correct slight defects.

Fig. 72. The colorless blender felt-tip pen applied to watercolor pencils blends the tones, producing a more compact and "impastoed" effect. It can yield very interesting results in certain kinds of work.

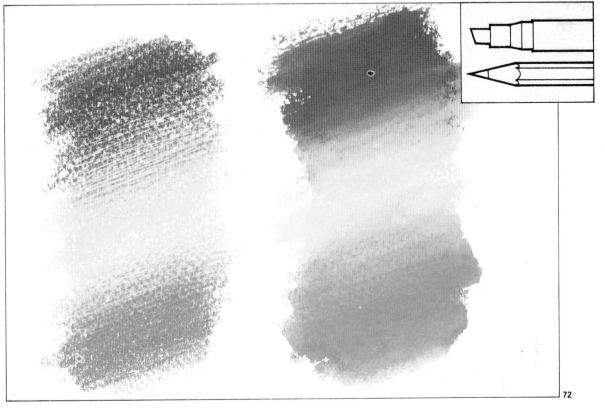

You will paint in just three colors: cyan, magenta, and yellow. And although you have such a small number of colors, you shall have all the colors of the rainbow at your disposal. Note this fundamental rule:

With only these three primary colors, cyan, magenta, and yellow, you can obtain as many shades as there are in nature, including black. This is because every tone is composed of a part of blue, another of magenta, and another of yellow in different proportions, according to the color in question. And it could not be otherwise, for the simple reason that in any source of light throughout the whole universe there are only three colors: the so-called *primaries*. The rest are mixtures of these.

73

HOW TO PAINT WITH ONLY THREE COLORS AND BLACK

Notes on color theory

Physicists talk about light colors. Artists talk about pigment colors. They are not exactly the same, but I will not get into this subject, or I will be in deep water. Let's go straight to the pigment colors.

There are three basic pigment colors with which all the others can be mixed: *magenta*, *cyan*, and *yellow*. They are called *primary colors*. Mixing them in pairs, you get the so-called *secondary colors*. Thus:

Magenta + Cyan = Deep Blue
Magenta + Yellow = Red
Cyan + Yellow = Green

Knowledge of secondary colors is not just a piece of cultural information. It is of vital use to us. These colors are also the *complementary colors*, the ones that produce the most intense color contrast when juxtaposed with the primary color that is not in the mixture. Or:

— Deep blue is the complement of yellow.
— Red is the complement of cyan.
— Green is the complement of magenta.

And we can even talk about *tertiary colors*, which are obtained by mixing the primaries and the secondaries in pairs. They are orange, crimson, violet, ultramarine, emerald green, and light green. Look at the color wheel on the right. I will discuss the concepts at more length.

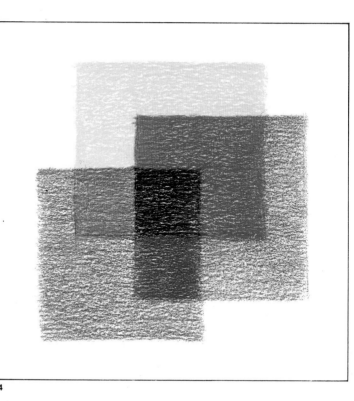

74

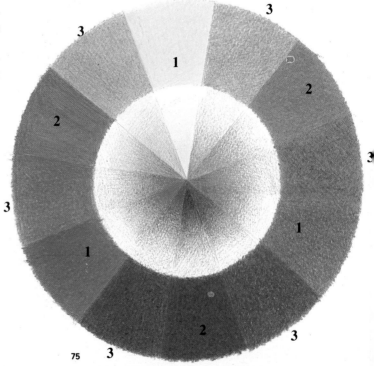

75

76

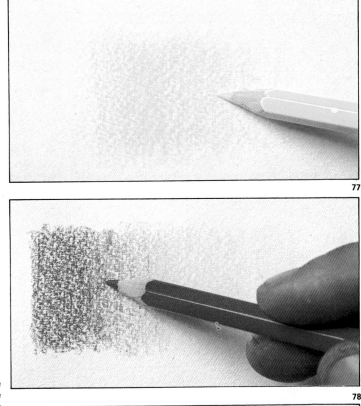

77

78

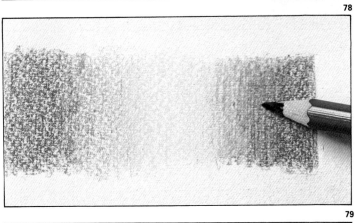

79

Fig. 74. (Previous page, top left.) Here you can see how the three primary colors, yellow, magenta, and cyan, superimposed in pairs produce the secondary colors: red, deep blue, and green. If you superimpose the three (center picture), you get black.

Fig. 75. The so-called *color wheel*, or *chromatic circle*. The mixture of primary colors (1) produces the secondary colors (2). If you mix the primaries and the secondaries, always in pairs, you get the tertiary colors (3).

Figs. 76 to 80. See in these figures how it is possible to get all the colors of the spectrum by using just three of them, the three primaries reproduced in Fig. 76. But don't just take this statement on trust. Try it yourself. Prepare some scraps of medium-grain paper and get to work. This exercise will also be useful for practicing grading, which must be continuous, and retouching the intermediary areas so that no whites are left and there are no abrupt jumps in color.

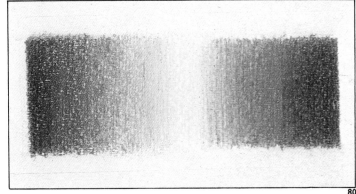

80

The final test

I have set to work to demonstrate everything I have said about color and specifically about the three primary colors. I have drawn the same model in two almost identical versions (as you can see in Figs. 81 and 82).

Who would think that for the first version I used twelve colors and for the second just four? No one, surely. But that is how it is. And I would invite you to do a similar exercise. You will see for yourself how with the modest equipment of the three primary colors plus black, it is possible to get practically the same pictorial result as with twelve pencils.

I have already said that with the three primary colors you can obtain all the colors in nature. Even black, which you could also have dispensed with (obtained by mixing the three primary colors in the same proportion). No doubt you will be wondering why, if you can work with just three or four colored pencils, you should complicate your life with boxes of up to 72 colors, as mentioned at the beginning of the book.

Well, let us take it bit by bit. It is true (as has been demonstrated) that you can work with only three or four colors. But it is also true that the professional prefers a wide range of pencils. It makes his work easier, avoids the accumulation of layers of color on paper and means that he can obtain lighter and more fluent final results. He also saves time. One thing does not detract from the other.

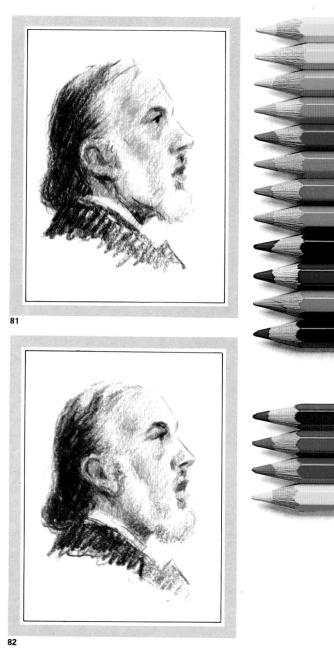

81

82

Figs. 81 and 82. Here you have palpable proof of how you can obtain a wide range of colors by combining the three primaries. The first portrait (Fig. 81) has been done with the twelve colors that can be seen to the right of the illustration. The second (Fig. 82), only with the three primaries plus the black, properly mixed.

Know the value of complementary colors

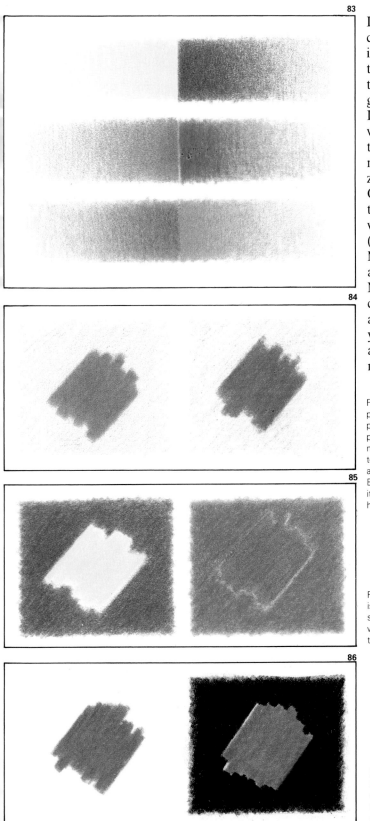

83

84

85

86

I have already said that knowledge of complementary colors is of the greatest importance: we know that when juxtaposed (placed side by side) they are the ones that strike the eye with the greatest color contrast.

In practice, contrast is interesting when it is not used in excess. Applied to a picture, contrast should be in small notes, but within an overall harmonization based on a predominant tone. Obviously, except in the cases where the artist quite clearly wants to paint with ranges that make a strong impact (like the artists of the *Fauve* school, Matisse, Derain, or Vlaminck, for example). But that is another story.

Now is the time to say that, besides color contrast, whose main exponents are the juxtaposed complementaries, you can also talk about *tone* contrast and *simultaneous* contrast. See footnotes to Figs. 85 and 86.

Fig. 83. (Above.) The complementary colors juxtaposed are the ones that produce the greatest chromatic contrast. It is basic to know this when painting and harmonizing a picture. But be careful when using it: contrast is not easy to handle successfully.

Fig. 84. (Left.) *Color contrast.* This is the result of juxtaposing two different colors. It can be more or less marked, depending on the colors you use. You already know that complementary colors, related to one another, are the ones that provide the greatest color contrast.

Fig. 85. *Tone contrast.* This is produced between two stains of the *same color* when one is darker than the other. Naturally, a very wide range of tone contrasts can be obtained according to the intensity of one stain and the other.

Fig. 86. *Simultaneous contrast.* This is, in fact, an optical effect. It consists of the following: all the colors seem darker if seen on a light background than if seen on a light one. And vice versa: they seem lighter on a dark background.

A necessary exercise

Action! You will use the three primary colors (and not a single other one) to obtain the values that, numbered from 1 to 36, can be seen on these pages, like the gradings below. This is a basic exercise for you to get to know the nature of the pencils and the astonishing results of the mixtures. Prepare a medium-grain paper; also other sheets of ordinary folio paper to put under your hand while you

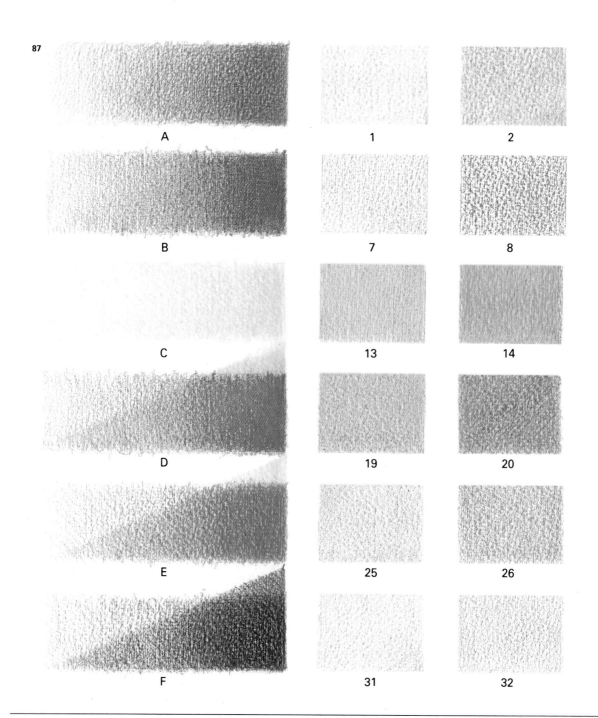

87

are painting to protect your work from being rubbed by the hand "running" the pencil. Pencils with well-sharpened points, but not too sharp. And one thing: this is a practice, but take care with the execution, and be sure to get a beautiful finish. It is a good idea to get used to doing things well from the beginning. Let's start.

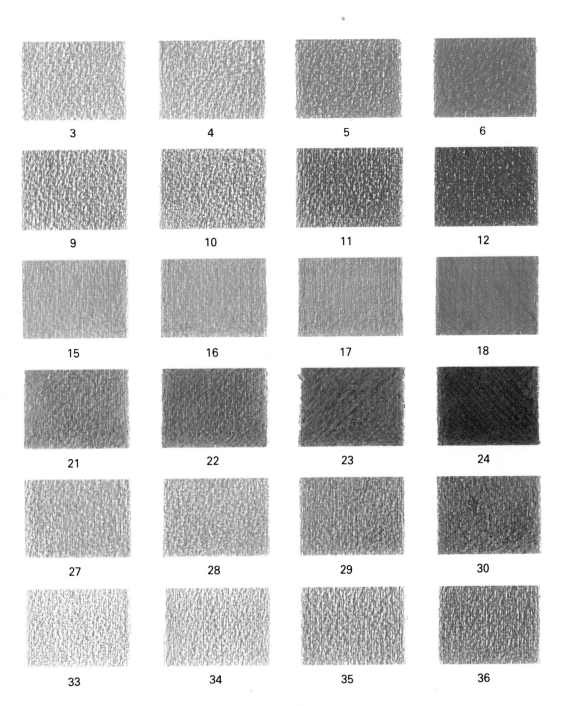

3	4	5	6
9	10	11	12
15	16	17	18
21	22	23	24
27	28	29	30
33	34	35	36

Range of greens

But first, let us do the three primary gradings that you have on page 46 (Fig. 87 A, B, and C). It is best to start with them so that you discover the reaction of your three pencils according to whether you apply more or less pressure and you acquire manual practice. Let us start the grading from the left, pressing the pencil gently (barely brushing the paper) and gradually pressing harder as you move to the right. The last lines are very intense. And all this is done in one movement, without a pause. The result must be perfectly harmonious, so that we have a color grading without abrupt jumps. Once the grading is done, retouch certain areas to equalize the color if necessary. Do the same for the other two primaries. And practice beforehand as much as necessary on other sheets of paper. The illustrations D, E, and F, in the same Fig. 87, show how the secondary colors are obtained by mixing the primaries.

But we will put this into practice now.

The range of greens

In Fig. 88 A you can see how the color green is obtained: by mixing blue and yellow.

Let us go on with the grading (Fig. 88 B). Prepare the paper and take the blue and yellow pencils. First, a grading of blue, done as explained above. Then, on top, another grading of yellow. Practice, practice. Try as many times as necessary on separate sheets of paper until you are sure that you can do one perfect one, the "good one." But *do it*, don't just look and read these pages. Now you will paint the six different greens that you see numbered from 1 to 6.

First paint the blue of the six squares from the palest to the most intense, trying to make a gradual increase in tone. The color must be absolutely flat. That is, no darker parts in some areas of the squares than others. Redo and correct this aspect if necessary.

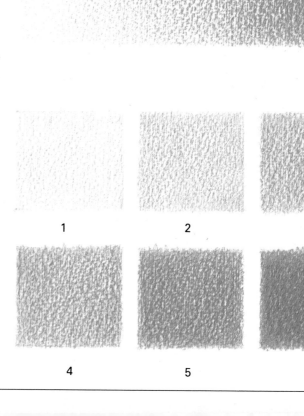

88

1 2 3

4 5 6

Range of blues

The primary color cyan and the primary magenta (a crimson or red tending toward pink) mixed together produce a deep blue. See Fig. 89 A.

Let us start the grading immediately. First the magenta; be careful! This color stains deeply, and you can get a more intense tone than you want if your hand slips even a little. So take care. Then the cyan. You already know the mechanics of these gradings. Apply yourself to it and practice as much as you need to obtain a similar result to the one you see in Figure 89 B. And retouch afterward to equalize the areas that do not show proper uniformity.

When the grading is done, I think you will find it fairly easy to manage the range of blues numbered 7 to 12.

I will insist on one thing: each stain has to be absolutely uniform, in a flat color. The same tone should be everywhere, neither more or less color in any part of the square.

First the six magentas, from less to more. From the palest to the darkest. Always draw in the same direction and draw straight: the direction best suited to your hand, but always straight. Be careful with the pale tones: I have already said that magenta stains deeply. You can find a reference point in the intensity of the magenta that must appear in the last square by looking at illustration A in Fig. 89. The blue of the same square can also be observed in this illustration.

The blue obtained is the second secondary color that we have mixed from two primaries. I would remind you that it is also the *complementary* color of yellow; that is, the color that has not been used in the mixture. Just as the green made before is the complement of magenta: a strong contrast.

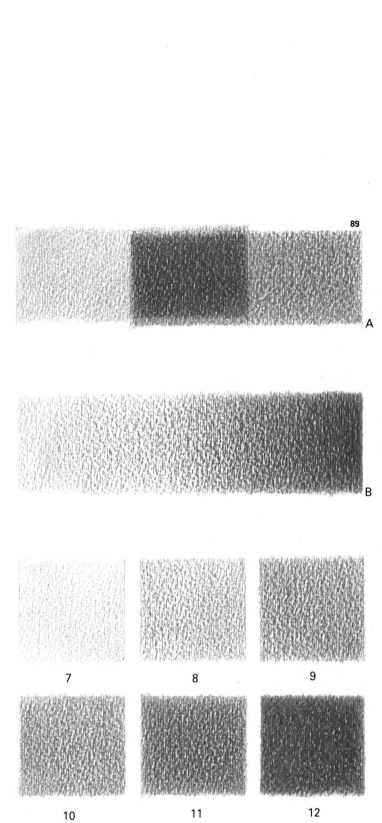

89

A

B

7

8

9

10

11

12

Range of reds

The primary color magenta plus the primary color yellow give us the secondary color red, which is the complement of cyan, or luminous blue.

Let us go on with the grading. Well, I don't have to explain to you how it is done. Just to point out that you start with magenta. And don't forget the order that I am giving you for mixing the colors. Generally, when you have to superimpose them in later exercises, keep the same order; it will make everything run more smoothly. The reason has already been mentioned on previous pages.

Let us start on the range of reds numbered 13 to 18.

First, all the magentas. In squares 13 and 14 you must obtain a very, very pale pink; in 15 and 16, a more intense one; in 17 and 18 a really strong magenta. And then the yellow, with more energy than the magenta. In squares 16 and 17, with *a lot of* energy. In 18, press for all you're worth.

As you can see, the authentic red color is the last. It is in fact the secondary you were looking for. The previous ones are actually orange tones, the result of a slighter pressure of the pencils. Well, you now have the three secondary colors, each in a range of six tones obtained by mixing the primaries in pairs. Now you will start to obtain a series of tertiary and quaternary colors (still with your three basic ones), which are constantly applied in painting.

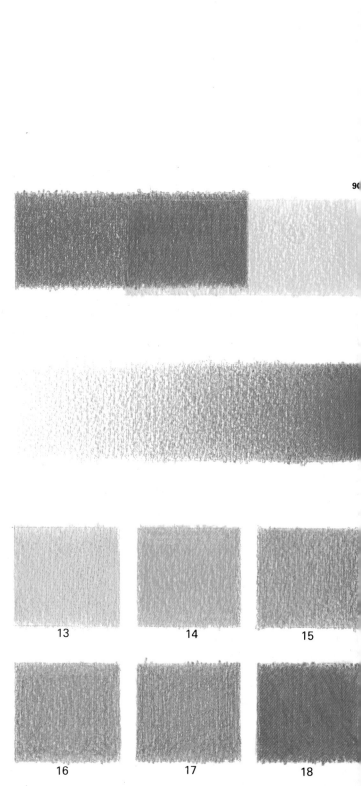

13

14

15

16

17

18

Range of ochres and siennas

You are still using only three colors, but with one variation: you put three layers of color instead of two, as you have been doing up to now. Notice how strange: you will use only cyan, magenta, and yellow, but in spite of that in each case (see the following pages) you shall get ranges of ochres and siennas, of "dirty" greens or khakis and bluish grays. How can this be? It is because you apply each primary in different proportions.

See in illustrations A and B of Fig. 91 how the color sienna is obtained. First you mix cyan and magenta (A), then add yellow (B). But in what proportions?

Let's work and you shall see. On this occasion, don't paint all the cyans and then all the magentas and then all the yellows. Manufacture tone by tone, mixing the three colors in each square before going on to the next. Of course, it is *absolutely* indispensable to practice beforehand on separate paper.

As a basic guide, I can tell you that to obtain siennas and ochres you must always put *more magenta than cyan,* then apply the yellow quite intensely. That is, when you mix the cyan and the magenta it will be necessary to get a crimsonish (or reddish) violet, on which you will later add intense yellow.

Squares 19 and 20 are ochres. From 21 on, we have the siennas. But all this you must practice yourself on separate paper, time and again, putting more pressure on one color or another until you see for yourself which is the most suitable proportion to be applied in the mixtures.

And when you finish each box you can keep working on it. With the three colors in your hand, you can accent one color or another until you have adjusted them to the exact tone you want.

I can assure you that these practices are truly fascinating.

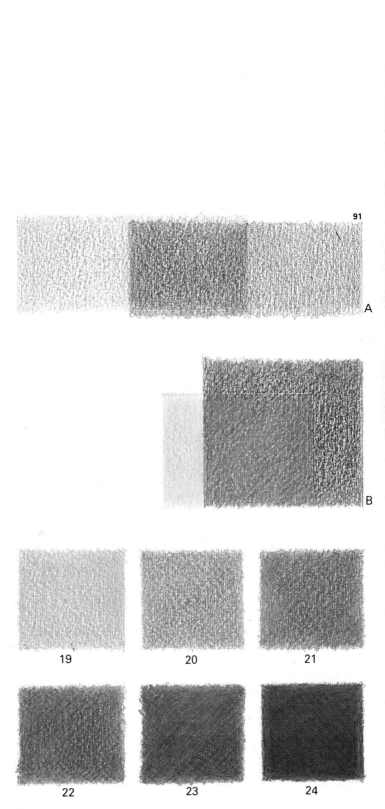

91

A

B

19 20 21

22 23 24

The khakis and browns

One more note about color theory before we continue. In painting there are:

— The range of warm colors (yellows, oranges, reds, lights greens),
— the range of cool colors (blues, emerald greens, bluish violets), and
— the range of dull colors.

Well, you have been working with this last range since the previous page, since you started practicing with the ochres and the siennas. This range is formed by mixing two complementary colors in different proportions (green and red, for example) with added white, that is, the white of paper, when painting with pencils. The range is composed of grayish or "dirty" tones, such as browns, ochres, khakis, greenish or bluish grays, and so on.

Khaki is, one might say, a dirty green. You will try to get it in the usual grading with your three primary colors. Let us do the same as in the previous exercise: finish each box before moving on to the next, trying to reproduce the colors numbered from 25 to 30 in Fig. 92. The colors are the same: cyan, magenta, and yellow. The proportions vary. As in the previous case, you first have to obtain a violet.

The rule of thumb is: *a balanced proportion of cyan and magenta in the first mixture to obtain a slightly bluish violet, and an intense application of yellow.*

See for yourself, try it. You know this is what you have to do. More or less cyan, more or less magenta, more or less intense yellow until you get the tone you want. And afterward you can still retouch with one pencil or another, painting in each box until the tonality is perfectly adjusted.

I have talked about the khakis, but not the browns. In order to paint dark khaki browns, you must keep making mixtures from tone 30 on.

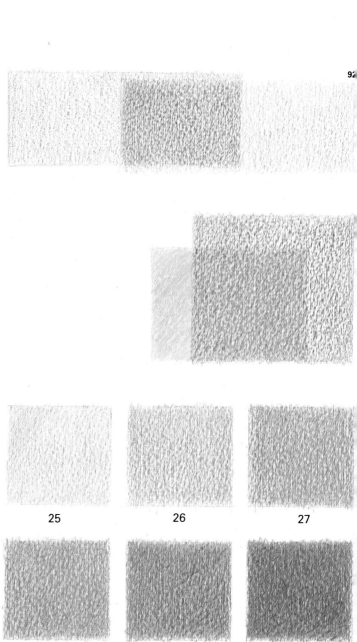

92

25

26

27

28

29

30

The bluish grays

Pretty colors. You can also make them with the same three modest pencils. I will give you the basic rule for getting this range:

For the violet, *more cyan than magenta*; you will start with a bluish violet. Then, application of yellow *gently, a medium yellow*.

Begin to work, please; or rather, begin to try it out before you decide to do the definitive exercise that consists of painting six boxes similar to the ones you see numbered 31 to 36 in Fig. 93. I insist: these preliminary practices are absolutely decisive if you really want to figure out the nature of the primary colors and their mixtures. I can give you some general guidelines, but the true mastery of color comes only from the discoveries you make yourself in practice.

At last you have finished a series of exercises that, I can assure you, are the basis of painting. Perhaps you do not realize all you have learned while working on the 36 colors you have just obtained. I would go so far as to say that you have learned *everything* about color, and whatever is added later will just be the occasional detail on a quite substantial base.

Now you can aspire to enterprises on a larger scale.

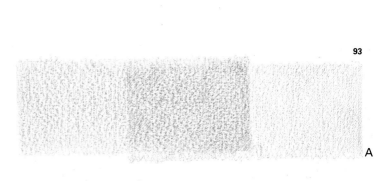

93

A

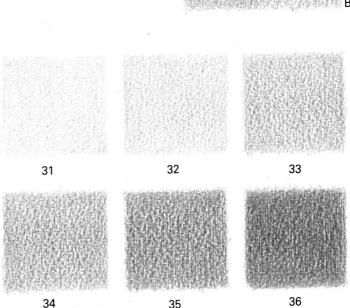

B

31 32 33

34 35 36

A step forward. In fact, *all* the steps,
because you are getting ready to paint
a "major" work, a finished picture
where you can bring into play
everything you have learned in this
fascinating practice of producing 36
colors with just the three primaries.
You will paint a landscape, no less.
But only with your familiar
companions: cyan, magenta, and
yellow, with the addition of black. Up
to now you have just been making up
odd colors with these three pencils.
Now you will apply your experience
in this subject to painting a landscape.
You will have to give value, shade,
"form," color, and light to all the
elements of the subject. Do you like
the exercise?

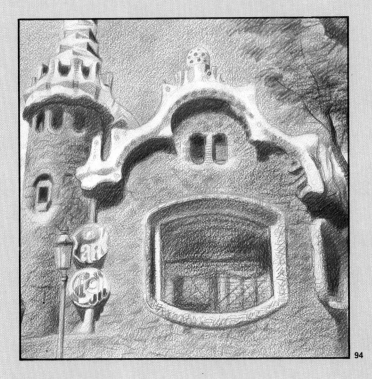

94

PAINTING A PICTURE
──── WITH ONLY ────
THREE COLORS
AND BLACK

Choosing the subject and range of colors

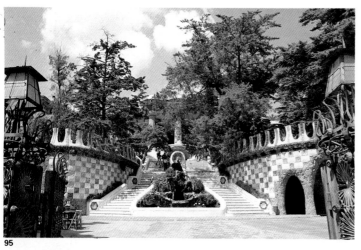

95

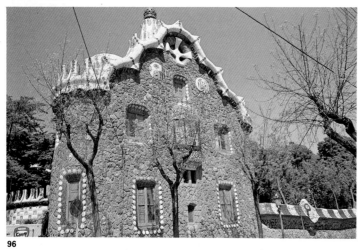

96

Figs. 95 and 96. Trying to find a model for painting with color pencils, I went to a park built by the famous architect Gaudí. There I took photographs like the ones illustrating this page. Afterward, in the studio, I chose the subject on the right (Fig. 98) and, using this photograph as a model, started to draw.

Fig. 97. This is the simple range of colors you will use to paint the landscape of Güell Park, the three primaries plus the black, all of them in their various gradings. By mixing them, you will get the many colors and tones you need.

97

To speak of Güell Park is to speak of Gaudí. Güell Park is in Barcelona, different from all other parks and designed by the famous Catalan architect. Fantastic shapes, strange decorative elements. I went there with my camera ready to take photographs of everything I liked. Then, in my studio, I laid them out. I had to choose one to paint. I decided on the one you see here.

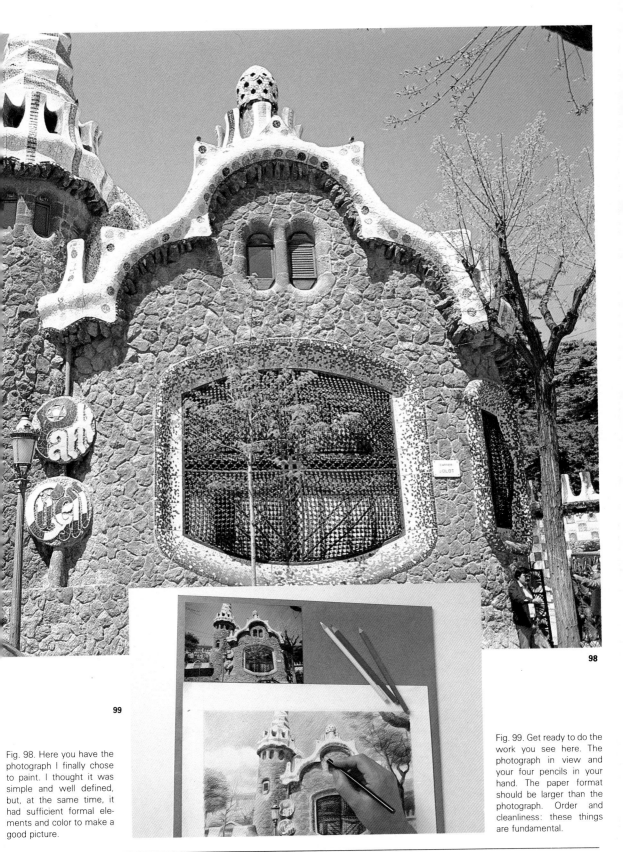

99

98

Fig. 98. Here you have the photograph I finally chose to paint. I thought it was simple and well defined, but, at the same time, it had sufficient formal elements and color to make a good picture.

Fig. 99. Get ready to do the work you see here. The photograph in view and your four pencils in your hand. The paper format should be larger than the photograph. Order and cleanliness: these things are fundamental.

Stage 1

Let us start work. You have the four pencils you will use at hand. Medium-grain paper: you already know this is the most suitable for working with colored pencils, or fine grain, which will do as well. How are the points of your pencils? Half sharpened? Sharpen the cyan properly. You will start with a fairly detailed line drawing of the model and you need a good point that will bring out the details. All ready? Let's go. Ah! Don't forget to place some clean folio type paper under your hand to protect the drawing.

Look at Fig. 100. A line drawing is the first thing you have to do to paint your landscape. The idea is to get the essential shapes of the model and the most important details down on paper. You look carefully to make sure you get the right proportions and measurements.

Work by pressing the pencil gently in case you have to erase anything. And when you are sure that all is well, do it again with more force, although not too much more. You are drawing with the cyan pencil. It integrates perfectly with the group of colors later on. Don't use the graphite pencil for this job. It doesn't go so well with the color pencils, and besides it may dirty the paper. Observe that in this first phase I have also marked the main areas of shadow. If you see that this rough sketch is creating a lot of work and you have to erase frequently, I would advise you to do it on a separate paper, this time with a graphite pencil, erasing everything you need to. Then transfer this sketch to the definitive paper by means of the system of copying described on page 101, but using the cyan pencil. Okay? On to the next stage.

Fig. 100. The sketch done with the cyan pencil: first step. This is a line drawing where all the motifs of the model are outlined, their shapes and proportions, as well as the more marked shadows.

100

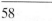

Stage 2

What you do in the second stage is obvious: gently color in all the areas of the landscape, and gradually start to mix the colors. You need to be able to see a first toning of the whole picture to start to work from there with greater precision.

For the sky I have used the cyan pencil, just that. For the central mass of the building I have mixed the four colors very, very gently: yellow, then red, a little cyan (just a spot). In the areas of deep shadow I have added more magenta and cyan as well as black, exerting a little more pressure. For the leaves on the trees, just cyan and yellow.

Try to give each part of the model the same tones that you see in the illustration. To do this, try the mixtures on other papers before deciding to get to work in earnest.

Alternate the pencils (keep them in your left hand) according to the needs of each moment: now the cyan, now the magenta, a little more black here, a touch of yellow there. Always be aware of the whole. The totality of the drawing must show a good tonal balance at every moment of the process. The great master Degas said that a picture must be painted so that at every moment it can be left without giving the impression that it is half done.

And pay attention to the line. It must follow regular directions. I have applied a constant line in this picture, straight and sloping. This is what I mean. You cannot change the direction of the line at whim without risking a shoddy picture.

Fig. 101. First general basic toning where you have already painted the whole surface of the paper, mixing colors from the first moment wherever necessary. It is a phase that must be executed very gently with maximum respect for the grain of the paper.

101

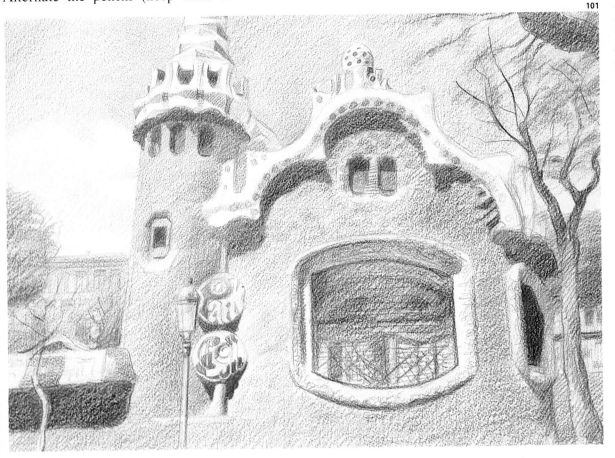

Stage 3

102

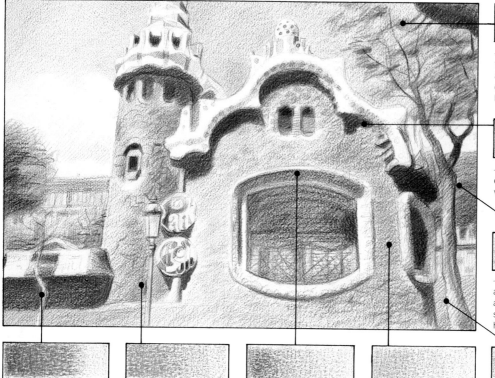

—For this background tone add a touch of cyan and yellow. Darken downward with the black.

—Intense shadow. It is a dark sienna strengthened with black.

—In the treetops there is a mixture of greens with an additional sienna in the shadow zones. You know how to do that.

—Add more cyan, a fair amount of magenta, and yellow. You will get a sienna. Then darken with black.

—An ochre. You already had it in the first phase. Strengthen it with the three primaries. Try on other sheets of paper.

—More cyan than magenta for the shadow of this window. Darken later with black until you obtain the desired tone.

—An ochre like the one at the base of the tower, but slightly lighter. Gently add red and black. A touch of yellow.

—Here put more red and a little cyan and black, but all very gently.

Fig. 102. Intermediate phase. On the first layers of color that you have already made, you will add value, shade, volume, and specific details: you apply color here and there, never taking your eyes off the model and the painting.

If you observe Fig. 102 carefully and compare it with 101, you will immediately understand exactly the process of gradual finishing of the landscape we are working on. On the basis of the color you got at stage 2, you have to *model* the *forms* you observe in the model bit by bit. This means that what you see in the photograph are in fact forms with volume that you have to represent on flat paper. This is done by modeling: that is, *shadowing*. The shadows are the medium you have to give the illusion of three dimensions. In short, you have to darken the areas of the model that appear to be most in penumbra. In practice, you have to intensify the color with your pencils.

Observe: I have darkened the right side of the tower and the right side of the front façade; I have given more col-

or; I have intensified the pressure of the lines. I have hardly touched the areas on the left, which have more light. They are still almost in the same state as in the previous phase. This is modeling.

And I have started to give more precision to the details (which are vital for providing the picture with concision and coloring); for example, the red strips of the balustrade on the left, or the lamp, or the hollows of the windows.

I have applied more color to the treetops. Note the lines. They do not follow the direction of the others. This is valid, not only because the structure of the crowns has its own laws, but also because of loose, flexible lines in a specific area that dynamize the whole.

Stage 3

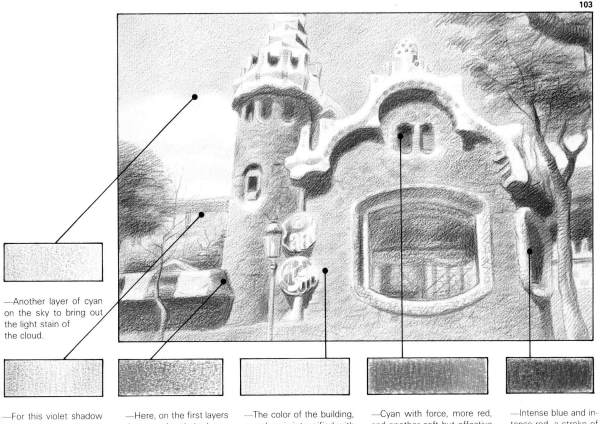

103

—Another layer of cyan in the background, you will add more red and, on top, more cyan. More red again if the tone is not adjusted.

—For this violet shadow in the background, you will add more red and, on top, more cyan. More red again if the tone is not adjusted.

—Here, on the first layers that you already had, you add yellow and red. A touch, a tiny touch, of cyan.

—The color of the building, an ochre, is intensified with more yellow, a little red, and a touch of black.

—Cyan with force, more red, and another soft but effective layer of black.

—Intense blue and intense red, a stroke of medium yellow, quite tenuous. And black.

You will see that the title says "Stage 3" and not "4." Well, although I have divided it into two reproductions so that you can follow the work process in more detail, in fact you are still at Stage 3, or the intermediate stage, immediately before the final one. You are still on the same job: valuing, detailing, specifying.

This is the moment when you work most feverishly. You have the model and the picture in front of you; you look at one and the other; you realize that here you have to intensify a tone, that there you have to specify a detail, intensify an outline, put another layer of cyan on the sky to bring out the cloud, and so on. And always, from the first moment, working from less to more. And with great care.

Remember what we said some pages ago: you cannot "overpaint." If this happens, especially at an advanced stage of the work, you have ruined it all because the colored pencil is difficult to rectify.

In the footnotes for this page and the previous, I present a sample of the tones of each area of the landscape. As you can see, with the same colors you can get quite different shades according to the proportion in which they are mixed and the pressure with which they are applied. The quality of the pencil also demands a certain finesse of execution by the hand. And do not forget something very important: it is best to apply some colors first before mixing in others. You will find examples on the practice pages where you got 36 colors with the three primaries.

Well, you have almost finished.

Fig. 103. You continue with the intermediate phase. You shade, value, outline, and darken. Everything from less to more. You should intensify tones by adding layers of color where it is densest. This is the most thrilling moment of the work.

The finished picture

The picture is ready. Or rather, finished. Observe this last phase carefully and compare it with the previous one. What has happened? Everything is much better defined and, if you look carefully, you will see that almost all the new elements have been done with the cyan and black pencils. I have used them to define outlines, specify details, and darken areas of shadow (for example, in the treetops). And in fact I have *drawn*: the grille of the large central window, the blinds on the small windows, details of the lamp, some linear effects of the tree trunks. And notice the central façade and the right-hand part of the tower. Everything is dotted with small, fluent, direct lines running in different directions. They define, more or less impressionistically, the stones with which the building is made. And look at the white window frame. You will see a series of lines of the same type (fast and loose) that I have used to simulate the small mosaics or tiles that appear in the model.

In a word: in this last phase, I have abandoned, so to speak, the classic method and let myself be carried away by a freer and to more spontaneous spirit, touching here and there with the point of the pencil to specify various details of the picture with direct lines. As I said, somewhat in the impressionist manner. This may be the most difficult phase for you if you have not had much practice in these tasks. Try, though; you can even copy the lines you see in my work. And practice on other sheets of paper first.

Well, the work is finished. Satisfied? Of course you are. Well, if you are pleased, do what every artist does: sign it. And then frame it. The best way is English style, as you can see on the next page: frame and mat. Then hang it wherever you like it best. Ah! And when your friends and family ask you how you did it, you answer as if butter would not melt in your mouth: "Well. . . . It's nothing. . . . I painted it with three colored pencils. . . . That's all."

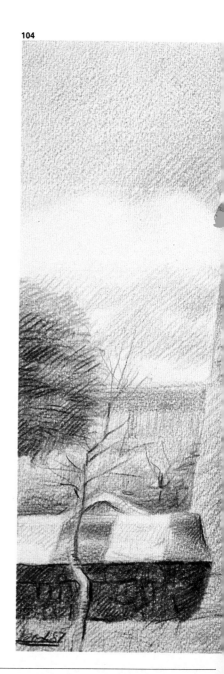

104

Fig. 104. The finished work. Notice here how bold linear effects have been achieved with the black, especially in the grill-work and window shades and in the outlines of the façade masonry. It's hard to believe that everything was done with just cyan, magenta, yellow, and black.

Fig. 105. Your first work deserves to be framed. Look how I've mounted mine, English style with dark mat in a shade of brown that brings out the overall tonality of the work.

105

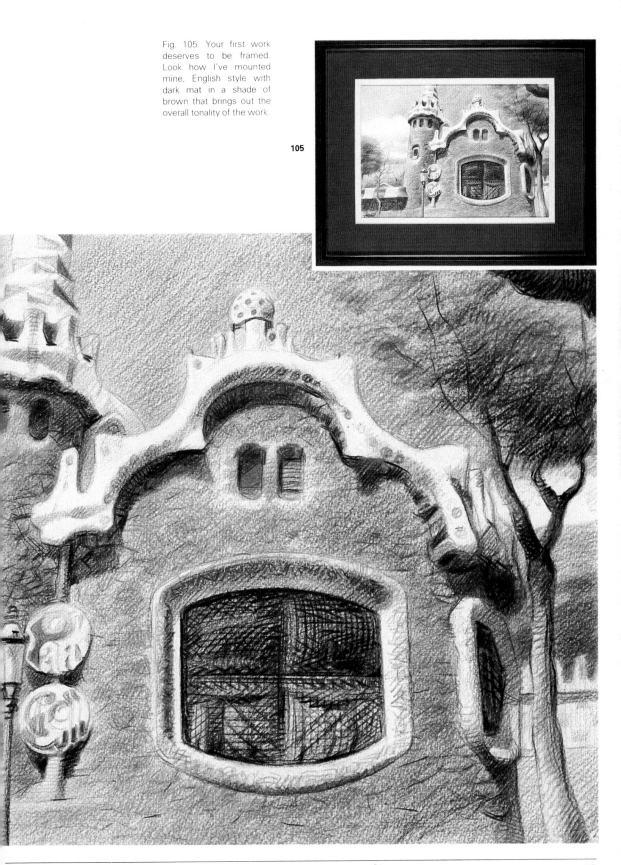

Step by step you are getting somewhere.
And you will take one more step on your
journey working with colored pencils.
Two novelties: you will paint from *nature*
and you will draw with twelve colors at
once instead of three.
It does not seem like much, but these two
new approaches are a truly decisive
apprenticeship. For example, you will
understand more clearly that shades never
contain just one color. And you will have to
sharpen your eye to capture them and train
your hand to reproduce them successfully.
You cannot darken with black this time;
you will have to do it with other colors.
The models are simple geometric figures.
This exercise is absolutely basic if you are
to launch into even more complex
enterprises.

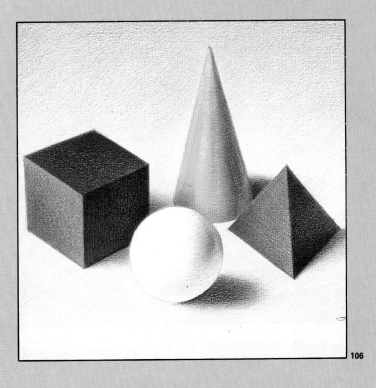

106

PAINTING A STILL LIFE IN FULL COLOR

Geometric still life

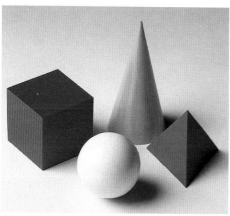

Fig. 107. This is the still life you will now paint. Although it is composed of geometric figures, it is a still life. The models are inanimate.

A cone, a cube, a pyramid, a sphere. The cone, yellow; the cube, red; the pyramid, blue; the sphere, white. These are the elements that will compose your *geometric still life*. The cone, the pyramid, and the cube you can manufacture yourself with bristol board in the colors indicated. But not the sphere. A tennis ball will do very well. If I tell you that the pyramid may be 3 1/2 or 4 inches (9 or 10 cm) high, calculate the proportional size of the other elements by observing the photograph.

You have the models. Now you have to place them in the most harmonious form possible. So, let's *compose* the still life. I suggest the layout in Figures 109 and 110. I have tried out various arrangements and finally opted for this composition, which seems to me to be the most balanced. But you can vary it as you wish. Place the figures as you like best if you are not satisfied with our suggestion. But do not forget to place a gray bristol board under the models.

And the light. You have to light the still life in the way that best brings out the volumes on the figures. Do you mind if I impose—for now—a side spotlight like the one you can see in Figs. 109 and 110? Our basic objective will be valuing; that is, you will do an exercise in "seeing" all the tones presented by the same color in each geometrical figure (for example, the yellow of the cone) and in interpreting these shades on paper using your beloved colored pencils. Now let's work with twelve. Don't think it's easier. You won't have the black for darkening. Shall we start?

Fig. 108. Here are the four elements that will make up your still life. A white sphere (which could be a tennis ball), a red cube, a yellow cone, and a blue pyramid. You can make the three last figures yourself with colored bristol board.

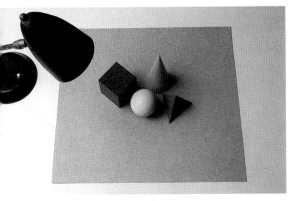
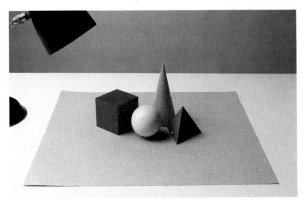

109 110

Figs. 109 and 110. This is the composition we are proposing. All the elements can be seen clearly, and it is a harmonious whole. Light from the front and the side—very important.

Fig. 111. We have broadened the range. Now you have twelve colors. Don't think it's going to be easier.

Three blues, two reds, a light sienna and an ochre, two yellows, and three grays. This is the range you will use for your geometric still life. The darkest blue, as you will observe, is practically a violet. You could say that it is a blue-violet. You will not use the grays to darken the colors of the figures. They are for the background: the gray bristol board that you have put underneath the geometric objects. Because of the luminous spot and the shadows thrown by the models, there is a wide range of grays in the background, which you will have to capture and reproduce as best you can.

111

Preparation

Fig. 112. In this frame of reference (which you must not draw), I have put letters on the faces of the cube and the pyramid so that you can follow the explanations in the text more easily. You can also see, in gray, the general tonality of each figure and of the shadows they throw.

112

Do you remember the rough sketch you did to start your landscape in Güell Park? Now you will start in the same way (Fig. 114). You always start a painting like this. You already know what it is all about: a line drawing done with colored pencil; in this case, harmonizing with the colors of each shape, I have done the drawing in ochre, blue, and gray.

On this occasion you are looking at *real* volumes, and you will find it harder to capture the forms of the models. So that you will not get lost, compare some dimensions with others; that is, the dimensions of the geometric objects among themselves. The inclinations of the cone and the pyramid should be drawn, observing the angle they form with the vertical lines of the cube. Measure, compare, taking the lines, heights, widths, and inclinations of the models in front of you as a reference.

Now on to the second phase. Let us start to add values . . . But first, wait a moment. I want to talk about two things. Look at Fig. 112. It is a reference illustration. Throughout the work process I will be pointing out to you

what I am doing, and to make things easier, I have put letters on the faces of the cube and the pyramid so that you can identify them easily whenever they are mentioned. You can also see immediately from the illustration which are the main tones of each figure. Some faces are better lit than others, and on the same face different tones can be perceived. In the case of the cone and the sphere they are not faces. They are "round" objects, and their curved surfaces show, with varying areas of shading and blending, areas of greater or lesser luminosity.

And the line. Look at Fig. 113. I said the same when you were painting the Güell Park landscape. You have to try to work without forgetting for a moment that the pencil lines will keep to one particular direction. This direction generally follows the *form* of the volumes. On flat surfaces, straight lines. On curved surfaces, curved lines. I suggest that when you paint the still life, you draw the directions indicated in Fig. 113. This will not only produce a cleaner work but will give it a presence that will suggest better the reality you have copied.

Fig. 113. The line must follow the shape of the volumes. Here you have a guide to the directions of the lines of each model as I have done them. Try to adjust to this guide.

Fig. 114. The point of departure: a drawing done with ochre, cyan, and gray already marking out the main shadow areas of the model.

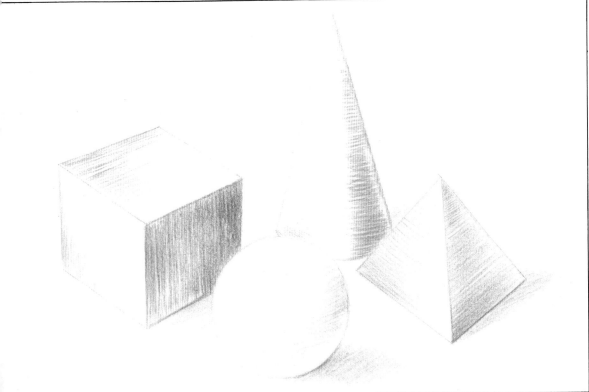

Stage 1

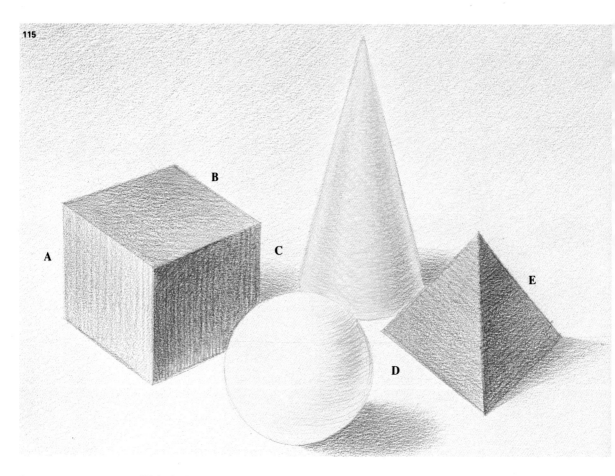

Fig. 115. General toning phase. The whole work has been painted and lightly valued. Maximum gentleness so as not to eliminate the grain of the paper. I have started to mix colors.

This is how your still life looks as you finish the first phase of the work. As always, you have covered the whole composition with color, already lightly and gently valuing the tones of the model. Let us take it in sections:

The background
Darker above than in the lower area. It becomes gradually lighter from top to bottom. Light gray all over. In the upper area I have applied dark blue very gently, grading toward the base and no longer using it in the bottom half of the picture.

The cube
All the faces are slightly valued. Face A is the lighter one, B is darker, and C is the darkest of all. On all three there is a very soft layer of light yellow and another layer of red on top. Observe that they do not show the same tone all over. At the upper left vertex of face A and the upper left of C, the color is intensified.

The pyramid
Light blue and dark blue in two soft superimposed layers. These faces do not have the same tone all over the surface either.

The cone
First, a very light coat of lemon yellow. Strengthen with warm yellow in the shadows on the right and left. In the shadow area on the right, I added ochre, which is more intense at the base.

The sphere
Light gray all over. Medium gray superimposed on the right area of shadow.

Thrown shadows
On the background gray I have applied magenta very gently.

Stage 2

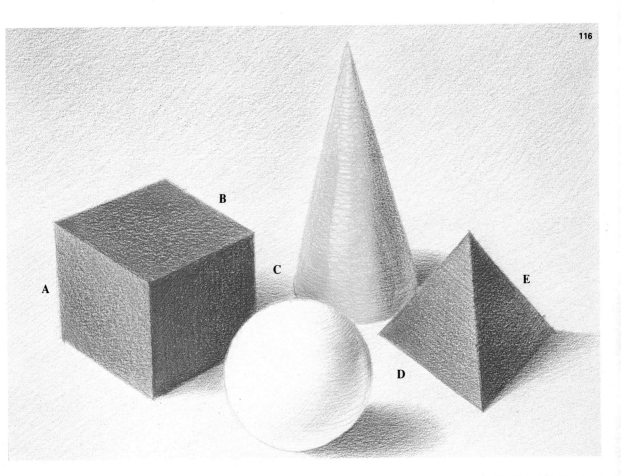

You keep valuing, creating effects of light, shadow, and increasingly precise reflections.
Let us see:

The background

I have accentuated the more intense tone of the background above with graded dark blue. I have added medium gray to the thrown shadows. Gray, also medium, at the base. Still not pressing the pencil too heavily, respecting the grain of the paper.

The cube

More red on all the faces to increase the intensity. A layer of yellow on top to create luminosity.
Face A: grading from the lower left corner to the upper right of the cube.
Face B: careful, you should add dark blue on the right, grading to the left.

The pyramid

The dark blue of faces D and E of this geometrical figure are intensified. The tone grows toward the lower left corner of face D, and toward the upper point and the lower left corner on face E.

The cone

Add sienna and red—gently—to the shadow on the right, respecting the grain of the paper. And also at the base of the shadow on the left. Observe the line carefully: it always follows the curved form of the figure.

The sphere

I have added light sienna to the gray that I had put in the shadow area. Observe that this shadow does not reach the edge of the sphere to the right. A touch of dark blue at this edge marks the blue reflection thrown by the pyramid—curved lines.

Fig. 116. Definitive tonal valuing phase. More color where there is more shadow, concretion of outlines and details. Watch out for the flat surfaces. They do not have the same tone all over. Try out all the mixtures on other sheets of paper before applying them to the definitive drawing.

The finished picture

It's over. The geometrical still life is finished. Take a good look at it before adding the finishing touches. In this last phase, as always, details have been specified, outlines have been strengthened, and some small areas of shadow intensified.

In the cube I have strengthened the lower line of face C to mark out the edge clearly, which specifies the figure better. I have added dark gray to the shadow thrown by the sphere. I have also intensified the darker areas of the pyramid (left and upper vertices of face E) by adding violet. And observe that the shadow thrown by this figure has two sectors: one darker, near face E, and another lighter next to it. I have brought out this darker sector with cyan. In the sphere I have done practically nothing new. It was finished in the previous phase.

And the cone. See how from the base upward in the center of the shadow zone there is a curved line that marks a reflection. I have accentuated it too. Look at the shadow thrown by the cube. I have not added dark gray as in the case of the sphere, but yellow. This shadow is dyed by the yellow reflection of the cone. On the other hand, I have added violet to the shadow thrown by this figure, influenced by the blue reflection of the pyramid. This is also the moment to retouch certain details with a well-sharpened pencil, especially on some areas of color that have still not been properly equalized in tone. With care, this can be fixed now.

And that's all. Just as you did with the picture of Güell Park, you can sign and frame it. Well, before you frame it, leave it for a few days. It is possible—it happens to all of us—that then you will "discover" some details in your work that need a few rectifications. Accentuating a certain sector of color, outlining an edge Nothing much, of course.

Now you are the owner of two works.

Fig. 117. The finished work. Everything has been valued, modeled, and specified. The result is much richer in color than might have been expected from models that appeared so simple at first sight.

A

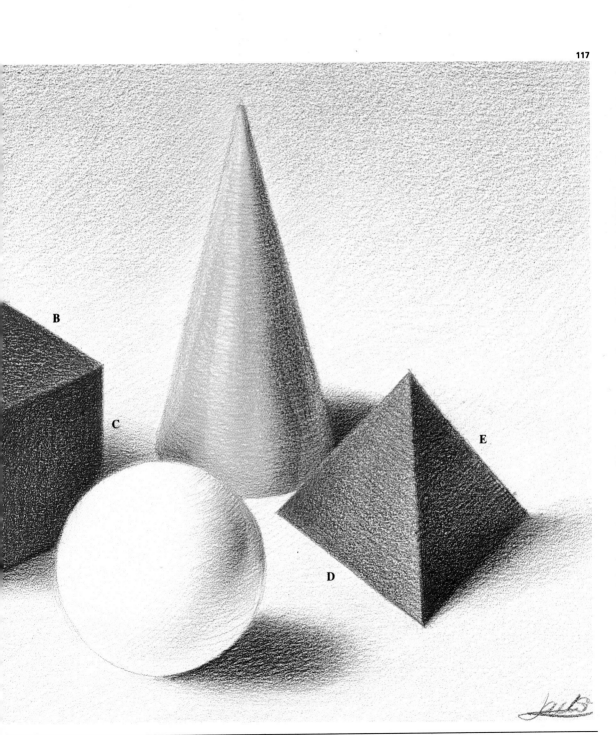

More and more pencils, more and more colors, more and more difficulties, but also more and more thrilling work with more artistic interest.

There is no greater pleasure in the world than the pleasure the artist feels while working and executing a difficult work to his taste. You will soon be feeling this pleasure.

Now you will draw a female face and you will see another novelty that is also a challenge: *flesh color*. Flesh color is many colors, perhaps more than you can imagine. I have used eleven pencils, almost all applied to the model's face.

Yes, you have to go through this exercise. Do you realize the number of pictures there are that show human faces? I'm sure you're waiting to begin. So let's begin.

118

—PAINTING—
A FEMALE FACE

Capturing a likeness

You have the model here, on the right. But it is better if you use the illustration on page 83 for working. You can see everything better. You will draw this young lady with the straw hat. I will describe the steps I have followed to get the final result, and you will happily tread behind.

Use medium-grain drawing paper with ordinary paper beneath your hand, as always, to protect what you have drawn, and use the range of colors you can see in Fig. 125.

In the first place, draw a line sketch in cyan as in Fig. 120. If it is too hard, do it on a separate paper with graphite pencil and copy it afterward as explained on page 101.

Our basic objective is to work with flesh color. On the opposite page, by way of an initial demonstration, you can see how this tone is produced. It includes as many as seven colors. Did you ever imagine that many? Read the footnotes carefully.

119

Fig. 119. This is your new model. Really pretty. A girl with a straw hat. But use the illustration in Fig. 132 as a reference when you work. Everything is clearer there.

Fig. 120. As always, you begin with a rough sketch in blue pencil. Be very careful. It is not easy either. If you like, do it first on a separate paper and then trace it on the paper for the final drawing.

120

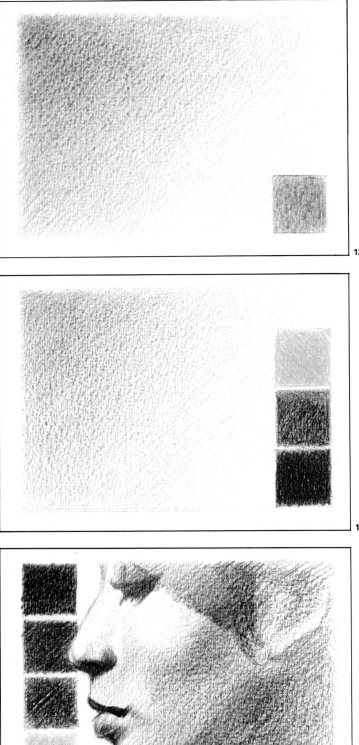

121

122

123

Fig. 121. Let us investigate the flesh color before you go any further. It is fundamental. Light sienna is the basic color for painting flesh color. And you can do it with a pencil of that color. As you can see here, intensifying from less to more, you can get a good range of gradings.

Fig. 122. But you can also get sienna color by mixing yellow, magenta, and red. It is a better way, as you may note. With the mixture of these three colors you get a more vibrant sienna color: it is possible to shade a reddish or crimsonish tendency or a more luminous one with the yellow. Nevertheless, notice that this color is just the base. It is not *all* the flesh color. The skin tone is much richer and more complex.

Fig. 123. Besides the base color, flesh produces shadows, reflections, and reverberations in other colors. This is reality. Apart from yellow, magenta, and red, flesh color contains the greens and the blues, which are fundamental for the shadows. Achieving a good flesh color depends on a suitable conjunction of these seven colors that you see in the illustration.

Preparation

Before you begin, one word of warning: take care with the direction of the line. Look at the drawing plan on the right. Without making it an absolutely rigid rule, it is important that your line adapts more or less to the directions and curves that you can observe in this drawing. As I have said, the lines must *follow the forms of the volumes*. This is the way to achieve a work with a clean, coherent presence.

There is also a word to be said about cleanliness. This drawing has to be completely neat and tidy, especially in the flesh areas. A female face cannot have stains or dirty patches. So be extremely careful. More than ever, go from less to more, underpainting if necessary. There will be time to accentuate the color. But don't rub out, please, don't try to rectify. If this happens, it is better to start the picture over again.

Are you ready? Then take the eleven colors illustrated below right in your left hand and down to work.

124

125

Fig. 124. See the general guidelines in this plan for the direction the pencil lines should follow when drawing the different parts of the head. As usual, you have to "model" the form of the volumes. Work approximately like this.

Fig. 125. Your range of eleven colors that at some time or other you will apply to the flesh color. Isn't it astonishing that human skin provides such a rich range of shades?

Stage 1

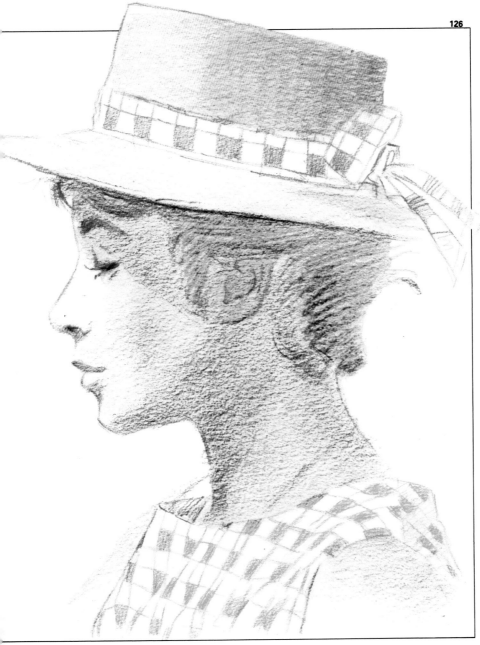

126

Fig. 126. Notice the colors I used in this first phase of the general toning. Follow the same process.

—*In the whole drawing, including the shadows, except in the ribbon on the hat and the dress:* soft yellow.

—*On the face and the arms:* pale pink from right to left, grading toward this area, which is fully lit. This part is not touched. You have obtained a pale orange by mixing it with the yellow you already had.

—*Ear and lips:* soft magenta.

—*Shadow of the face, neck, and arms:* light green. Gently mixed with the previous colors, it will give an effect of lighted shadow. On the cheek and the chin, emphasize the green more, but not much. Just a little more.

—*Neck:* strengthen the whole neck with a very soft red.

—*Shadow of the nose:* very weak magenta, more green at midtone.

—*Hair, eyebrows, and eye:* dark blue. Outlining on the eyebrow, eyelid, and eyelashes, though not too much, so as not to detract from the effect of the atmosphere. Draw the hair following the direction of the comb.

—*Straw hat:* sienna and green in the shadow areas, grading to the right. And give it another layer of yellow.

Finally, retouch and strengthen all the areas that require it until you achieve a toning like the one you see in the illustration.

For the general toning, you may not believe it, but there are already seven colors here. As always, you must first get the initial tonal valuing of the whole. It will do as a base to pass on to the second stage of more precise modeling. In the footnote to Fig. 126, I have shown you the colors I have used and where I have applied them. I can sum up thus: first I stained the whole head including the shadow zones with yellow, just leaving out the ribbon on the hat and the dress.

Then the softest of pinks on top, not reaching the left side of the face and the arm, which are fully lit. And the shadows, obtained with green, cyan, sienna, red, and magenta. Also dark blue for the skin, crimson for the lips and ears, and intense blue for the eyelid, the eyelashes, the eyebrows, and the nostril. But, most important, gently, respecting the grain of the paper. The lines follow the form of the volumes. Everything is very clean.

Stage 2

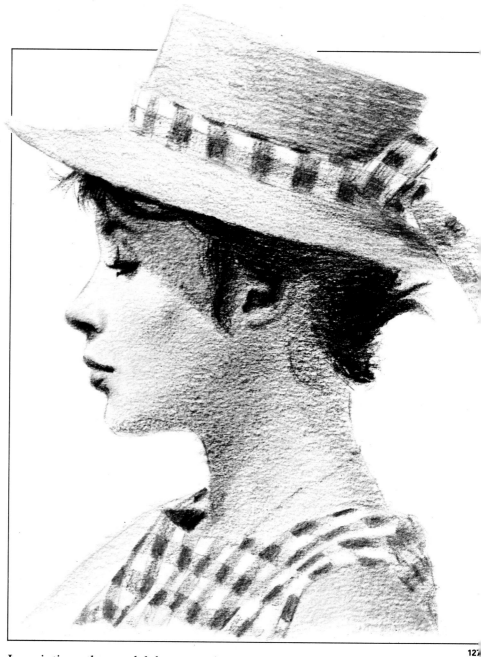

Fig. 127. Intermediate stage. This is how I worked:
—*Shadow of the temple, cheekbone, and cheek:* add more light green gently, and more yellow just on the temple.
—*Jaw and lower part of the chin:* you have to darken; use light sienna. Careful: light blue under the chin. And since you have this color in your hand, give a touch below the lower lip.
—*Nape, temple, and curl:* blue and black alternately. Let the blue be seen in some areas so that the black can "breathe." Around the side of the face, use light blue, magenta, dark green, and light sienna, so as to obtain the grayish and bluish tonalities you can see.
—*Eyebrow and eye:* black and dark blue.
—*Ear:* some more magenta, light blue, and dark blue, modeling the shape of the ear.
—*Lips:* more magenta. For the shadows, light blue and black. Don't touch the areas with sheen.
—*Shadow of the nose:* apply red, light green, dark green, and magenta, grading and modeling as you see in the illustration.
—*Nostril:* sienna and black, intensely.
—*Neck:* light green in the background, dark green and red, grading from more to less to leave the light green visible.
—*Hat:* light green and light sienna, grading in small lines.
—*Dress and hat ribbon:* dark blue, violet, and magenta. Observe the model carefully and work with these motifs according to everything you see there. We have nearly finished.

In painting, the model becomes less nebulous and gradually more specific, more and better defined. You have crossed the important intermediate stage of definition. In the footnote to Fig. 127, I have indicated which colors I used and where. But you can already see what I have done: I have strengthened the darker zones by applying and mixing a series of colors that at first sight might seem unlikely.

Light green and yellow for the shadow of the temple and the cheekbone (the yellow reflection of the hat is there); crimson and blues for the ear; light blue and black on the lips; reds and greens for the shadow of the nose; greens on the neck.

As you see, a symphony of color. And everything is completely logical. Things have their own colors as well as all the ones reflected by nearby objects. And, of course, while working I have respected the grain of the paper, leaving white points that allow me to apply new layers of color.

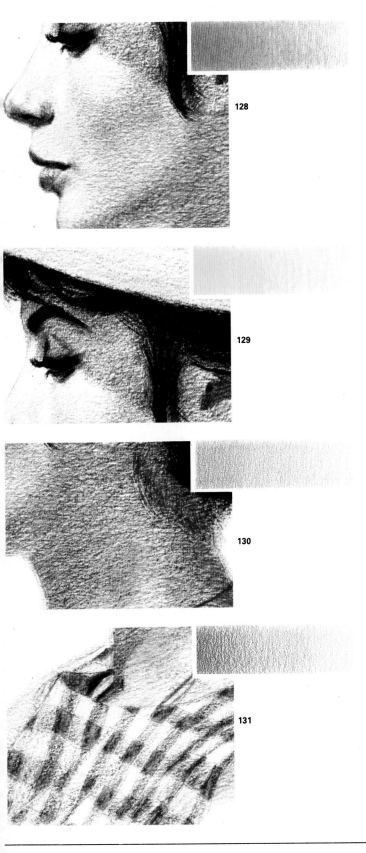

128

129

130

131

Let us go on to the end, toward the finishing touches to your work. I hope you don't mind if I go into detail about the tones of the face, because it is well worth it.

Cheekbone and cheek (Fig. 128)
On the base of soft yellow, soft magenta, and red, add light green, with tenuous strokes that don't cover the grain of the paper. More intense under the cheekbone, lighter on the rest.

Temple, curls, and eye (Fig. 129)
The shadow of the hat falls directly over the temple. You have already applied the basic flesh colors. The luminosity of the yellow and the pale green remains, but you can add a little more yellow to accentuate the reflection of the hat, which is the same color. Nevertheless, you must darken: I have applied light and dark blue.
Next to the curls, dark blue and green. On the eyebrow, the eyelashes, and the eyelid, black and dark blue. Now it does not matter if you "eat up" the grain of the paper.

Jaw and neck (Fig. 130)
Here there is shadow, but not as much as under the brim of the hat. The surrounding luminosity persists; I have not applied any blues. More green and light sienna. Everything will become darker, but the light within the darkness will be maintained. Dark blue on the nape, plus some dots of red.

Lower part of the neck (Fig. 131)
On the basic colors, apply more yellow. Here there is light again and you have to define it. A little light sienna too. Be careful with harmonizations of this area.

Finally, here is a general principle that you should keep in mind: on the basic flesh color (yellow, magenta, and red), light green, dark green, light blue, or dark blue are applied with greater or lesser intensity, according to the darkness of the shadows. To give luminosity, use yellow or light sienna.

The finished picture

Here you have the young lady's profile completely finished, from my point of view, of course, because the moment when a picture is "finished" depends on the criteria of each artist. Some finish more; some finish less. But there is no advice to be given here. It is up to the individual.

I would like to draw your attention at this final stage to some important details: that blue line under the chin and the left edge of the neck, which is just the reflection of the blue of the dress. The crimson applied to the ear in the first phase—which may seem strange—has, in the end, provided this ear with the slightly reddish tone that is usual in this part of the head.

Notice how at the back, in the hair, spontaneous blue lines have remained visible. I left them on purpose: these lines give the whole work "air" and atmosphere and remove any hardness from the dark outline of the hair. Also, please note how the painted lips, which in memory are simply red, actually contain magenta, light blue, and black. Finally, please note the absolute cleanness of the work; how, after quite a few pencil strokes on the paper, there are white points still to be covered; how you can still see the grain, something that adds atmosphere to the painting. What I would like you to see is that it is possible to get quite intense shadows without having to grind the pencil on the support.

I would also say that before tackling the last phase of this work, you should observe the model in full detail and retouch, accentuate, go over and specify the details that you have missed before.

I am sure that your third work is even better than the previous ones. I assure you that I feel as satisfied as you do.

Fig. 132. And this is th end. I have tried the whol time to express the idea o *a portrait painted from na ture*, a portrait with a fre spontaneous finish wit loose contours and ou lines, especially in the no essential parts, such as th hat, the hair, or the dress I have also attempted t show the characte istics of the medium, of co ored pencils, bringing ou the superimposition of co ors, all the while respec ing the grain of the pape and picking out the line a certain points so that yo can easily appreciate tha this head has been painte with colored pencils.

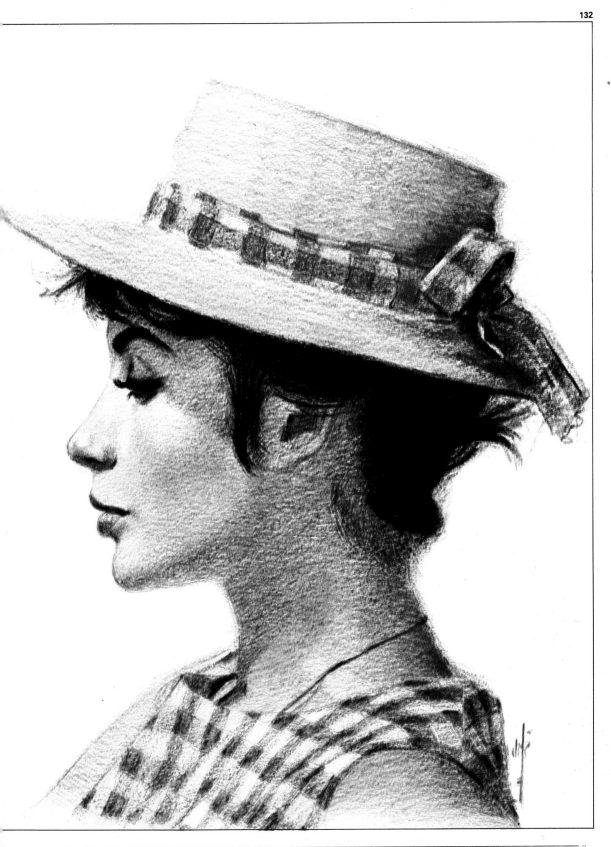

Remember what we said earlier about "step by step"? Well, I think you are now going stride by stride, because you have mastered the basic resources—and not only the basic ones—of work with colored pencils. You have used them so far in the classic way, following all the canons of art of all ages. The stride now consists of painting with watercolor pencils. The principles are the same; you just add water. And you use a brush, a tool that tends to alarm anyone not familiar with it. The proper handling of a brush in certain techniques with paint may not be easy. But now you will not use paint. Just clean water.

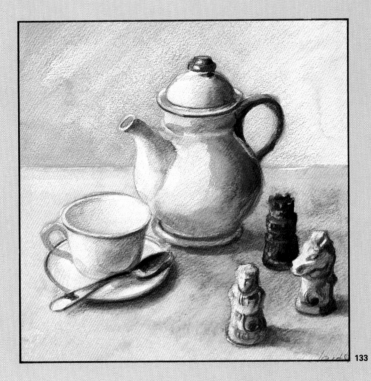

133

PAINTING WITH WATERCOLOR PENCILS

Preparation

A teapot, a cup and saucer, a teaspoon, and three ordinary chessmen. A pinkish base and a gray-sienna toned background. This is the model you will paint with watercolor pencils.

Do you think it has too little color? I have done that on purpose. In this way, with not much color, you will be better able to concentrate on the real technique of watercoloring.

You can try working with another similar model. But I would advise you to paint what you have in front of you first, following—more or less—the guidelines I will give you.

Everything is the same as when you work just with the colored pencils. A medium-grain paper, another protective paper under your hand, and the colors you see in Fig. 136. Plus the elements you need for watercoloring. Clean water in a large container and sable hair brushes. What type of brushes and what size? I have used three in particular: one large one for large areas (the backgrounds), number 12; another medium-sized for the bulk of the work, number 7; and a smaller one, number 3, for the details. Bear in mind that I have worked with the format that you can see on page 95.

What we will do is not a watercolor painting or a work with colored pencils. Although painting with watercolor pencils uses both media, it is something else. The watercolor pencil produces stains like watercolor, but different. Beneath them you can still see the pencil lines (see Fig. 135). This circumstance gives the works done by this method a mixed character, halfway between painting and drawing.

It has the characteristics of watercolor staining, but also the personality of lines drawn with pencil. The results are works that are fresh, fluent, and spontaneous. Really magnificent if everything turns out well. What about trying a few practice exercises before you begin?

134

Fig. 134. A simple still life with no great complications of color, so that you can concentrate more on solving the problems posed by watercolor pencils.

Fig. 135. Two blue stains on the left. The first, done with a watercolor pencil. The second with watercolor. Can you see the difference? The watercolor stain is flat, smooth. The stain done with the watercolor pencil shows the pencil lines, which gives it a particular character. The same is true of the red gradings on the right.

13

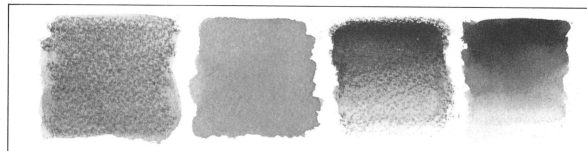

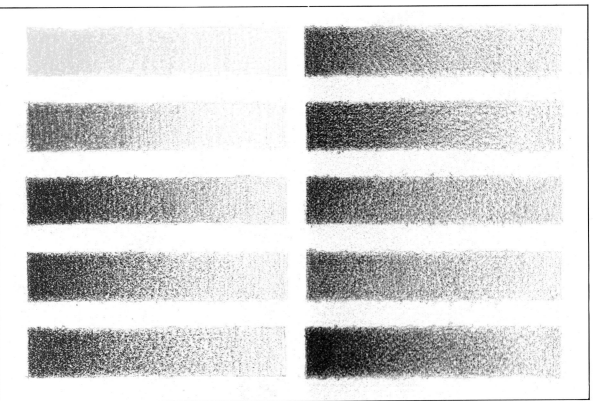

136

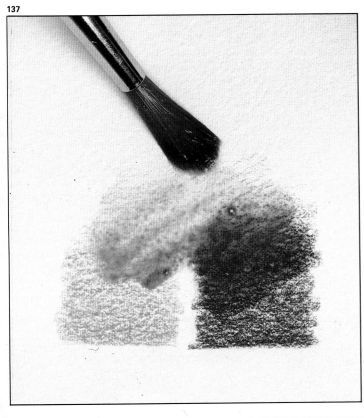

137

Fig. 136. Ten watercolor pencils for our still life with teapot, cup, and chessmen. It is the right range for a work in which reds and grayish siennas predominate.

Fig. 137. Practice this yourself. You can see how two colors are blended by the water. Water is "put" on one color or the other. Then you run it downward with the brush and join it to make a mixture of the violet and the pink. The water of both stains, which carries particles of color, mixes to produce a new tone.

Practice with watercolors

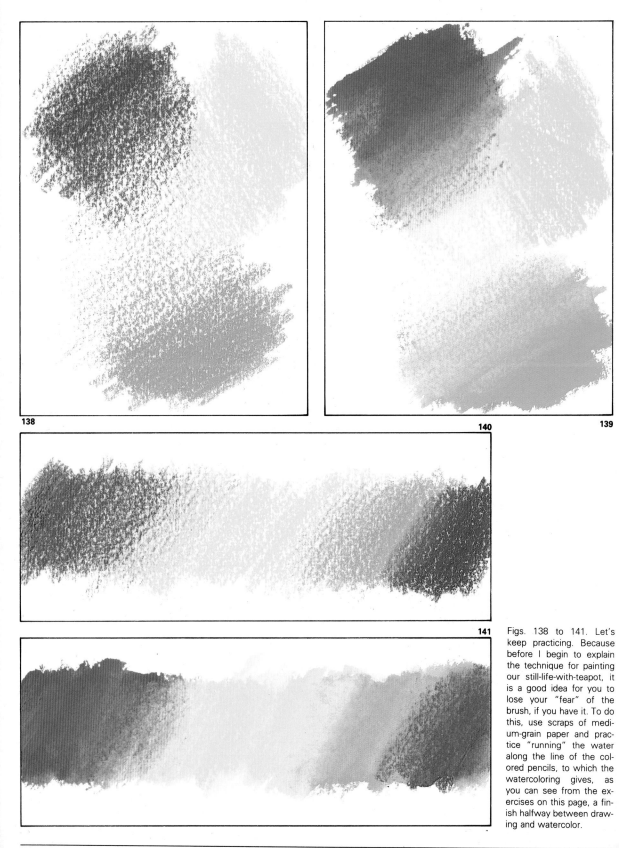

138

140

139

141

Figs. 138 to 141. Let's keep practicing. Because before I begin to explain the technique for painting our still-life-with-teapot, it is a good idea for you to lose your "fear" of the brush, if you have it. To do this, use scraps of medium-grain paper and practice "running" the water along the line of the colored pencils, to which the watercoloring gives, as you can see from the exercises on this page, a finish halfway between drawing and watercolor.

Rough sketch

You have practiced enough—and the "enough" is whatever you decide—to feel more or less secure enough to tackle the still-life-with-teapot enterprise.

You already know how to start: the rough sketch. This time I have done it with violet. It is the same as using blue. It is a color that will stay perfectly integrated with the whole. Remember to use a well-sharpened pencil. And, as always, you can do it on a separate paper and copy it afterward, as I explain on page 101. In any case, the basic shapes of the models must be perfectly marked out, as well as the main areas of shadow. Shall we start to color?

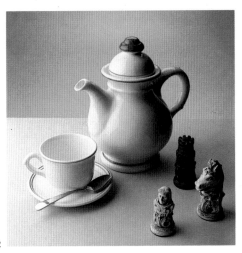

142

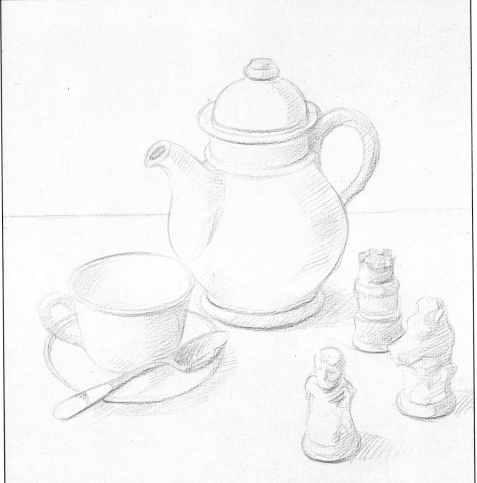

Figs. 142 and 143. Let's start your still life with a rough sketch, as always. This time it has been done with a violet pencil. That is correct: this color is later "absorbed" by the general tonality of the picture. The symmetry of the teapot may not be so easy. If you have problems, do the sketch on a separate sheet of paper and copy it afterward on the final one.

143

Stage 1

In theory, you work as if everything were the same, without thinking that you will have to watercolor afterward. You draw with a pencil trying to value, to model, to shade, to create light and penumbra. As always, from less to more, gently.

In Fig. 144 you can see the finished drawing. This time I have left out the description of the phases. Don't think I want to work any less. I just want you, this time at least, to investigate the illustrations and the model to see the way I completed this work. You now have enough experience to "see" it for yourself. Nevertheless, I will tell you that there is a base of light sienna and gray throughout the drawing, shaded and valued in the shadow areas with the other colors.

In the shadow of the cup and the teapot there is gray and sienna. Also violet (Fig. 145). In the interior shadow of the cup, I have put yellow (it is an area with light). The reds accumulate at the base. The background has been done with very soft layers of yellow, light gray, and sienna. The white chessmen also have light gray and sienna, plus a little yellow. So does the black rook, but here I have applied the darker gray and I have not applied yellow. The shadow thrown by the plate is composed of the background gray, intense sienna, and red.

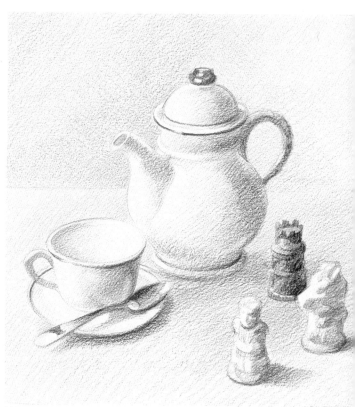

144

145

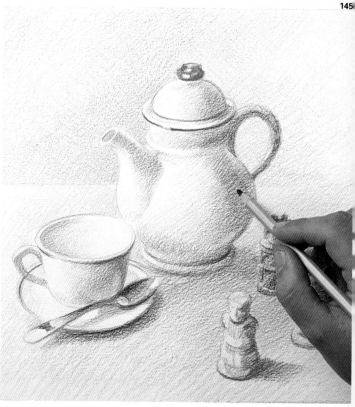

Fig. 144. Here is the finished drawing of the still life. The initial process has been similar to the one you practiced in previous work. First, a staining for general toning on which we later value and specify from less to more.

Fig. 145. First, value the bulge of the teapot with gray; then go on to the cup, the chessmen, and the background, mixing color as if you will not watercolor.

Stage 2

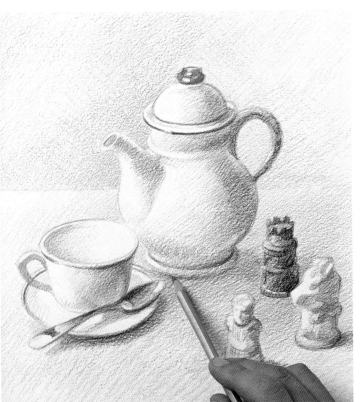

146

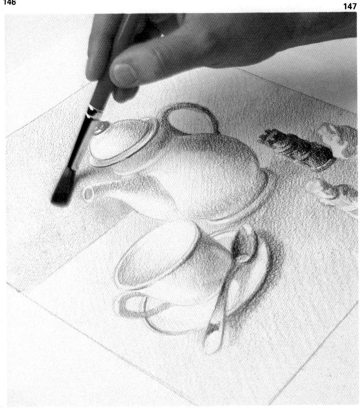

147

As always, at the end, I have marked out the darker profiles (Fig. 146), and I have given certain linear touches with very intense black or gray: look at the clean direct lines that mark the forms of the black rook. Or the line that determines the outer edge of the plate, or the reflection of the handle of the teaspoon. And the lines that outline the silhouette of the knight on the right. And the purple ornaments of the teapot and the cup.

Just as in previous exercises, except that now you have more independence, which you deserve, of course, after all these pages of working together. Now comes the moment to watercolor. This is really the objective that you wanted to achieve. As you see in Fig. 147, I have begun with the background. I take the large brush; I soak it in water and begin to apply it to this area. How? In an orderly way. I begin with the upper lefthand corner and go down along the side of the picture until I reach the edge of the table, with plenty of water. On the left, a sort of long puddle should remain. Then I run the water to the right. Little by little and *just the water*. Don't *rub* the brush on the paper; just run the water. When you see that the puddle is sinking, wet the brush again, until you reach the edge of the picture on the right, next to the table.

Fig. 146. Finishing phase. Tidying up of linear details, as you see here: intensifying the darker shadows in small areas; specifying and defining everything that needs finishing touches to strengthen and adjust.

Fig. 147. Now, you will start to watercolor. Using a brush and water, you have to "bathe" everything you have painted, but in a certain order. As you can see, I have begun to watercolor the background with plenty of water and a large brush, from left to right.

Stage 3

And we are still watercoloring. I have continued with the base toned in reds and magenta. It is the most logical way. I do the same with the background.

I have started on the left, with plenty of water, and run it gradually to the right. But this time it is more complicated: I begin next to the spout of the teapot, I move toward the left side, and I go down to the base of the picture, skirting the cup and the plate, then to the right, toward the white bishop. Here I put more water, plenty of it, and I go upward (note, not to the left); I pass between the plate and the bishop (Fig. 148), between the rook and the teapot, and I reach the edge of the wall. I needed to leave a large amount of water between the plate, the teapot, and the chessmen. Why? I have to get over the obstacle of the chessmen without the water drying anywhere. That would leave a stain.

Now I run the water to the left, passing between the bishop and the knight and, above, over the rook and the knight.

I have to look for a *continuous* route for the water and, when there are obstacles in the way, find the most viable formula for preventing the water from drying while we are branching off in several directions. Now you have to wait until what you have just done dries. Pay attention to this: *You cannot watercolor any new area until the previous one has dried completely.*

When everything is dry, I continue—model by model and with each part of each model. Let's use the teapot as an example. First the lid and then the rest of the container. Why so? To model the rest of the sector properly.

NOTE: you have to watercolor from the darker to the lighter areas. See Fig. 149. When I watercolor the body of the teapot, I begin with the more shadowed part and then I run the water toward the left, toward the lighter area: Be careful here too. In the small areas, as in the body of the teapot, you have to use a lot less water than in the background. Otherwise, there would be far too much. Not only that; to get a good grading in these smaller zones, you have to put a touch of water in one area, dry the brush with blotting paper, and then carry the touch of water to another area. The point is to reach the lit area with almost no water left. And do all this, bit by bit, until all the objects are complete. In small forms, like the chessmen, a little water is enough. Now we have finished.

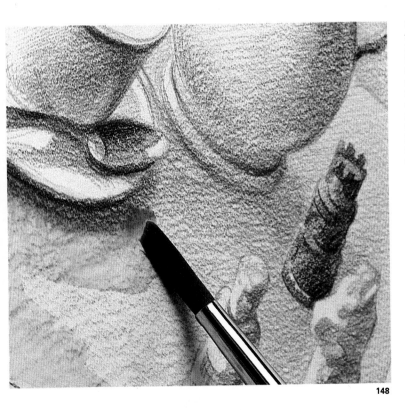

148

Fig. 148. In the background where objects are interposed (the teapot, the cup, the chessmen), you have to try to find the easiest and most direct ways for the water to run, taking care that it does not dry, until you obtain a flat watercolor without "cuts." Before you start to run the water, study the ways that you will make it flow.

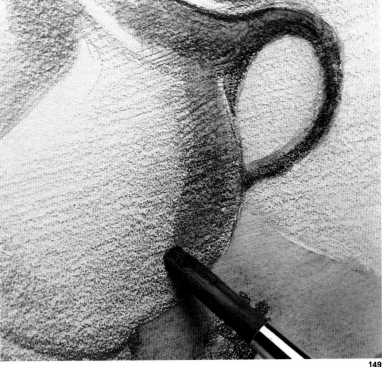

149

Fig. 149. And once the backgrounds are done, you begin with the other elements, motif by motif and part by part. Be careful with the gradings. Read the text carefully whenever it talks about this subject. And do not paint an area until everything around it is dry.

The finished picture

150

Fig. 150. I have finished. Is it a watercolor? Not quite. Is it a pencil drawing? Not quite, either. It is something else: a painting that shares the lightness of both media. There are color stains, but there are also lines. Something different, with the charm of freshness and spontaneity. I'm sure you will come to love this technique when you discover its secrets.

The work is finished. Here it is. It is as it is and there is no room for regret. The watercolor is done, and any rectification—although it is possible—will just dirty and deteriorate the work. If anything has not turned out well, it is best to leave it. For example, I have made the edge of the shadow on the bulge of the teapot too sharp. But that is how it will stay. And the effect is not disastrous enough to do the work over again. It has a certain impressionist charm. The only thing you can do, in the end, is retouch a dark area or an outline, *with pencil again,* but not much else.

And one word of warning: during the description of the phases of this exercise, I have been speaking through the mouth of the author of the picture; he has been commenting on his work while I was taking notes. The painter is Miquel Ferrón, a teacher at the Massana School in Barcelona and a magnificent watercolorist. Finally he said to me:

"There's no problem with watercoloring once you have learned to 'run' the water. That is the basic element in this technique, as well as order. From the darkest to the lightest and, in the background, from left to right, and the amount of water. But that . . . you can only learn with practice."

Thank you, Miquel.

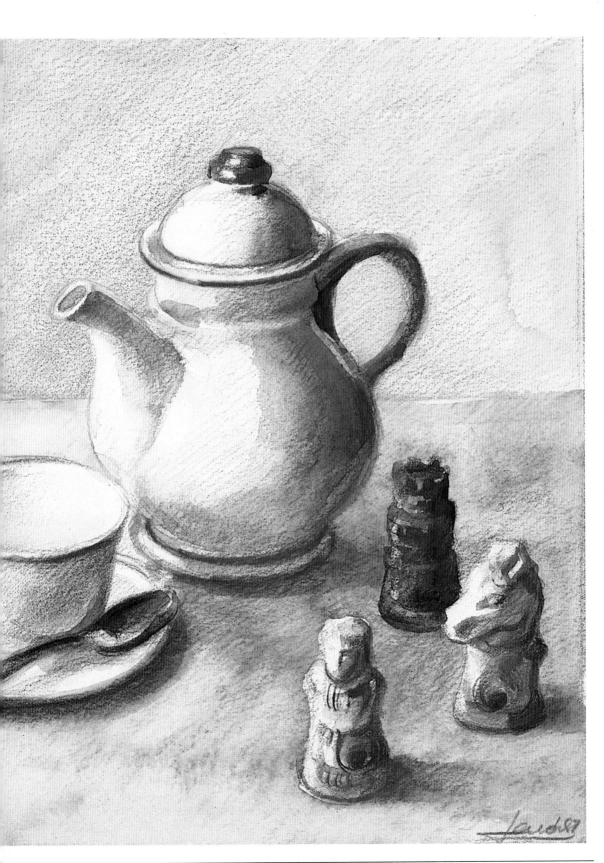

Holbein, Velázquez, and Ingres are all famous for their paintings, but also because they did astonishing portraits. There is no doubt that the portrait is one of the most attractive and most difficult of subjects.

You will paint one. A work that combines drawing, color, likeness, and shades. You will do a portrait of anyone you like: a member of your family, a friend, your fiancé(e), your child. From a photograph. This is not a second-rate method. The best artists do it all the time.

Look, I started out doing portraits of my family and friends like this until one day someone commissioned one. "I'll pay whatever you charge," he said, showing me a photograph of someone he loved. Then came a lot more. How about it?

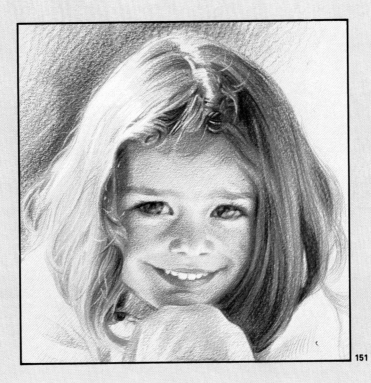

151

—PAINTING A— PORTRAIT

The photograph and the grid

You will paint a portrait of a relative or a friend—a portrait of your father for example; or of your mother, your husband or wife, your son or daughter, your fiancé or fiancée, or some relative you are fond of—and you will do it from a color photograph, painting with colored pencils.

The exercise will give you the chance to make an in-depth study of the trade and the technique of making one of these reproductions by means of the system of a grid on the original photograph, a system that is in common use, as you shall see in a moment, but that you may not know about in any detail.

You have all done this work at some time: drawing or painting a portrait from a photograph, using the grid system. I myself remember a series of ten portraits of famous musicians that I painted to decorate the assembly room of a musical society; I also remember the portrait of a dead person, the director of an large company, that I painted in oil some time ago.

And if we move from the field of art to the field of illustration or commerce, well, you have only to think of the infinity of portraits of politicians, scientists, and writers done by hand or pen and published in newspapers and magazines, portraits done from photographs, working and simplifying the "copying" with the grid system. This system consists basically of drawing on the model photograph, with the help of a ruler and triangle, a series of squares that are then repeated and extended onto the paper of the final drawing (Figs. 153, and so on). At first, the grid procedure seen in this way seems to be incompatible with the noble trade of the fine arts. But it is not. The system of making a grid of an image and enlarging, reducing, or simply copying it has been used by artists all over the world with no qualms and no scruples; these artists have even passed on the system so that those who succeed them will know how and when to use it.

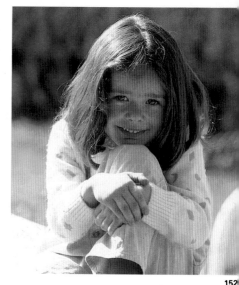

152

Leonardo da Vinci, for example, in his work *A Treatise on Painting*, gives a detailed explanation: "Draw a grid lightly on the paper on which you are going to work. Keep in mind the meeting points of the limbs of your model in accordance with those which the lines of the grid have shown you." Albrecht Dürer also talks about and illustrates the grid system. The procedure appears in countless sketches and studies by the great masters like Rubens, Degas, and so on, who applied the grid to their projects and later turned them into definitive pictures.

153

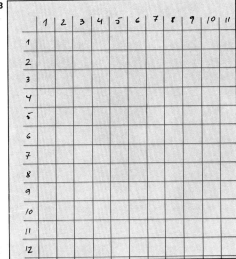

Fig. 152. You will paint the girl in the photograph with colored pencils. But not just any way. The painting *has to look like* the model. It is absolutely essential that it looks like her, because you are getting ready to do a portrait.

Fig. 153. This is a grid or a network formed of small squares (nothing but squares will do) done with ruler and triangle (set square). Above and to the left you put numbers or letters and numbers.

Moreover, the use of photography as an aid to the artist's work is quite common and generally accepted by professionals today. Of course, we assume that the artist is capable of sketching and constructing from sight, without making the grid; but we also understand that no one is inclined to make unnecessary efforts, wasting the experience and knowledge acquired through the trade.

So you will study the system without prejudice, beginning with the choice of a suitable photograph to translate into a good portrait painted with colored pencils.

154

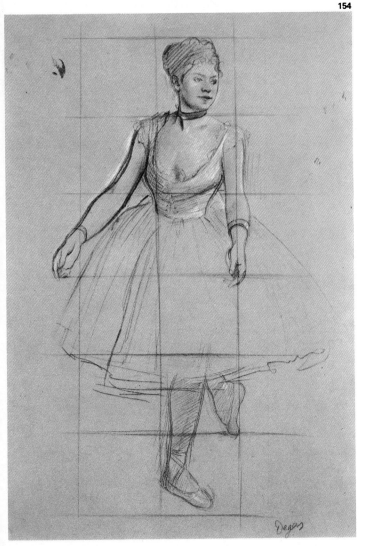

Fig. 154. The greatest artists from all eras have used the grid system in their work. Here is an example by the master Degas.

Choosing a photograph

155

156

157

Figs. 158 and 159. To draw the grid on the photo, you first make some marks above, below, and at the sides, marking out the frame you have chosen. Then you make the grid. If the space marked out does not give an exact number of squares, use as much as you need. It will not make much difference.

Fig. 160. On the right, you have the sketch on tracing paper. To trace, turn it over and stain with a soft pencil, as you see here.

Figs. 155 to 157. You have to choose the model photograph. The one that shows the best pose and expression, the best light, and the best definition. That is the first one, beyond doubt.

From a good photographic portrait you can make a good picture painted with colored pencils. But what do I mean by "a good portrait"? A good question. First: the photo should be no smaller than passport size. Second: the photo must be in focus and must show maximum detail in the features. Third: the lighting must be balanced, without excessive contrasts.

In short, a photograph that provides the maximum of artistic qualities from your—the painter's—point of view. The size must be large enough for you not to get lost in calculating dimensions and proportions; it must be in focus and it must have been taken in normal lighting conditions, without the hard, black shadows that lose the details of the features (Figs. 155, 156, 157).

Bearing these factors in mind, I have chosen the model photograph. In Figures 155, 156, and 157 you can see one good image and two photographs that are not suitable, one because of the unusual pose of the model (Fig. 156) and the other because of defects of focus and lighting (Fig. 157).

Now you will make a grid of the chosen photograph: mark out the frame or the part of the photograph you are going to draw with four lines (Fig. 158). Calculate the measurement of this frame so that each square measures no more than 3/8 inch (1 cm).

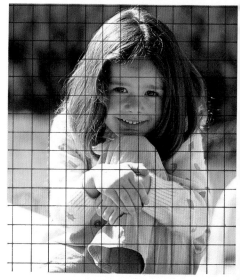

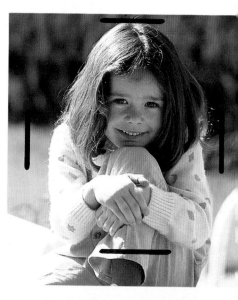

Copying onto the grid

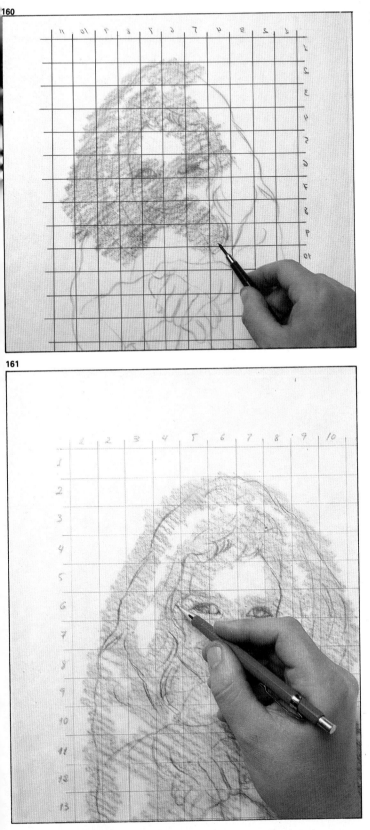

Draw the grid on the photo using a black ballpoint pen, working with ruler and triangle. It is important to draw the grid with the measurement perfectly adjusted and perfectly framed (Fig. 159).

So, now that you have reached this point, you could reproduce the previous grid and enlarge it on the definitive drawing paper. But you won't; you will put into practice a more laborious but considerably more effective, clean, and safe system.

1. Draw the image with the enlarged grid on tracing paper.

2. Transfer the image from the tracing paper to the definitive paper by means of tracing.

To do this tracing you will have to stain the back of the tracing paper, blackening it with a soft pencil such as a 2 or 3B. In fact, you are "painting" in black on the back of the parts that correspond to the drawn image, thus obtaining a sort of "carbon paper," which you can now use to transfer the image to the definitive drawing paper.

And there you are: now you can transfer the image. Use a normal grade pencil such as HB and draw (trace) gently, normally, without pressing down hard on the pencil, thus avoiding the formation of cracks or furrows made by the lead of the pencil on the drawing paper, something that could lead us to the sgraffito technique that we spoke about on page 37.

Fig. 161. You turn the paper over again and place it on the drawing paper, fixing it with cellophane tape. And then you go over the drawing carefully with a very sharp hard pencil. There you are. When you take off the tracing paper, you are left with a spotless sketch on the real paper without the grid.

From the tracing to the paper

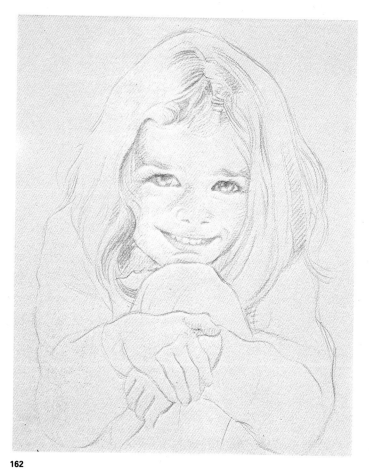

162

This is the drawing I have obtained with the tracing. As you can see, it is a black drawing in black graphite: the lead of the pencil with which you blackened the back of the tracing paper. Which contradicts what we have said in previous exercises.

But in this case it cannot be done any other way. The tracing should be very soft, hardly perceptible, so that at the next stage you can redraw with a light sienna color pencil. Well, let's start to color using the range you see here below. Once again you need the flesh color, and you have the colors you used already to paint the young lady with the straw hat: siennas, magenta, red, yellow, greens, blues, and so on. But now you are doing a *portrait*. You have to get a *likeness*. You have already done so to a large extent in the initial drawing, but the color will also be decisive.

In Fig. 164 you can see the first phase of the general toning. This time you will work almost on your own. You know: very gently, respecting the grain of the paper.

163

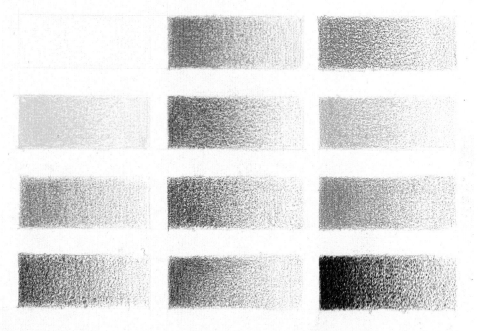

Fig. 162. Sketch with graphite pencil, the result of the work you did with the help of the grid once the tracing had been finished.

Fig. 163. The colors for painting the portrait. A varied range with yellow, siennas, magenta, reds, greens, and blue, the colors you need for the flesh color, remember?

Capturing the likeness through color

164

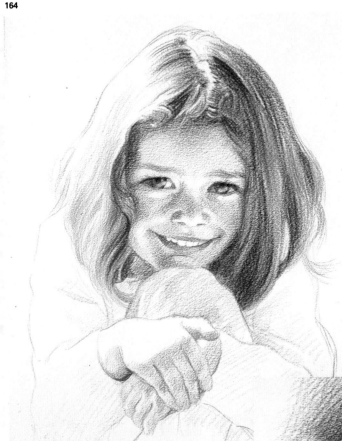

Fig. 164. Soft general toning; first valuing of your portrait. On the hair, intense light on the left and shadow on the right. Look at the face: it is in a kind of illuminated penumbra. Be very careful here. And never forget that you are painting a portrait. The slightest slip of the pencil can ruin the likeness.

Fig. 165. Intermediate phase. You value and intensify tones. You leave areas completely white, the ones where there is full light. Look at the crimsons of the face; observe carefully the way in which the pupils are painted.

165

Layers of yellow, magenta, red; more magenta on the cheeks, a touch of green on the shadow of the forehead. The hair is in full light on the left and in shadow on the right. The face is submerged in a kind of illuminated penumbra.

But now I want to focus on some aspects of the portrait. You already had 50 percent of the likeness in the sketch. But there is another 50 percent that you get with color. The complete likeness is achieved by specifying the small details that pass unnoticed by the layman: the corner of the mouth, the accentuated line of an eyelash, a gleam in the eyes, a particular shadow on the chin: a tooth (yes, a tooth) that is smaller than the others. This is basic and is done with valuing and deft touches of color.

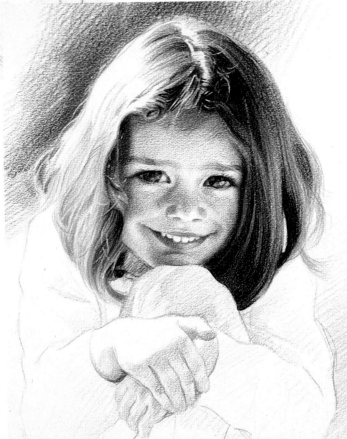

The finished picture

Figs. 166 to 169. Finishing your portrait. This is a crucial moment for obtaining the desired likeness and . . . for ruining it. The touches and outlines you give it now are vital: the accentuation of a color at the corner of the mouth, the outline of an eyelash, the strengthening of a wing of the nose with red, or a good definition of the hair with a very sharp pencil. This is the stage when you do not take your eyes off the photo and the drawing, searching for those small but decisive details that will define a good portrait.

Fig. 170. Work over. Magnificent, isn't it? (yes, I don't say so, other people do). Worth a frame and a space in your favorite corner of the house. The degree of finish is just right; it doesn't need any more or any less. The likeness is perfect.

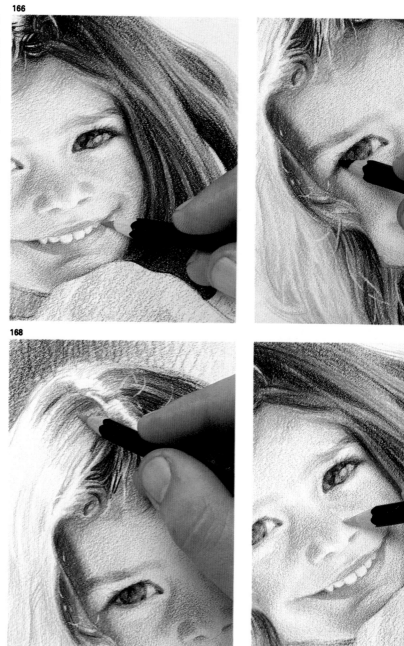

Four details about the finish. You have completed the next to last toning, and you are putting the finishing touches to the work. You are involved in the task I mentioned on the previous page: the concretion of that corner of the mouth (Fig. 166) or the line of the eyelash (Fig. 167); a little more shadow on the tip of the nose, adding a touch of red (Fig. 169). These are touches that, apart from completing the tonal details of the work, add likeness and expression. On the right, the finished work. As a painting in itself, I think it is good. As far as the likeness is concerned: it is exact. And yours? I am sure that you also have succeeded. Now take the photo of someone you would like to paint (or one of yourself to do a self-portrait) and get ready to do your first portrait with colored pencils with no help from anyone.

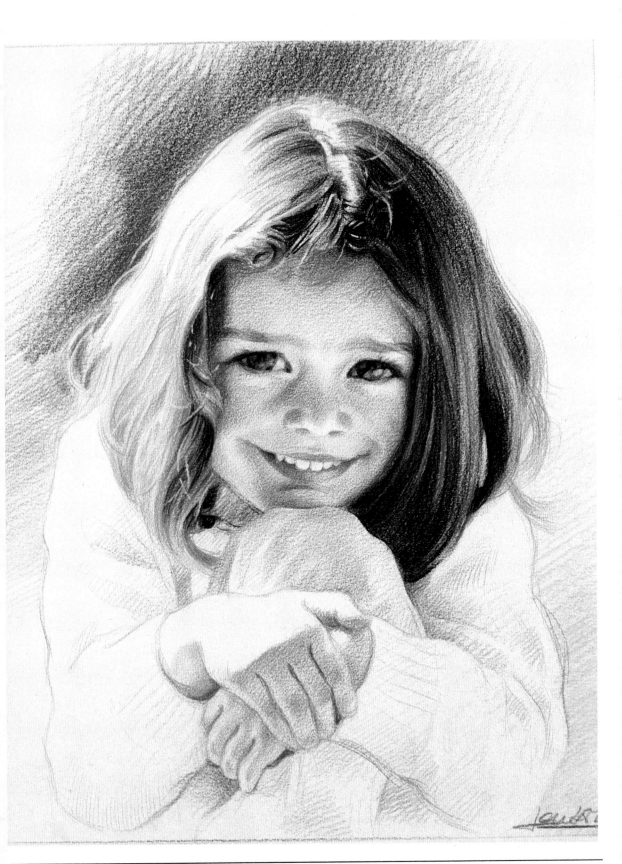

Choosing the most suitable frame

Is everything all right? Are you satisfied? Please go ahead and frame it. It will be a pleasant souvenir that you can always keep, always have beside you, the first portrait you painted in your life.

But don't overlook the frame. Don't settle for just anything. Each work needs a particular frame, the one that will best bring out its tonal qualities. Here are all the works you have painted framed with the most suitable frame. Don't your exercises look more important when you see this gallery of colored pencil paintings? Well, perhaps they are more than just exercises.

171

Fig. 171. There is an extremely varied range of frames for mounting pictures in all styles, manufactures, and tonalities. You have to hit on the right one.

172

Fig. 172. A wooden frame, deep sienna, with a golden edge and dark brown mat for your landscape in Güell Park. It matches and brings out the motif perfectly.

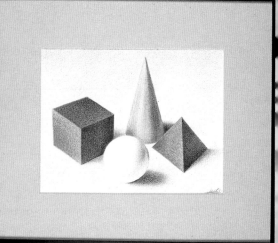

Fig. 173. The still life of geometrical figures is an elegant and cool work. A single black strip as a frame and a light gray mat give us a perfect atmosphere for this painting. **173**

Fig. 173. The still life of geometrical figures is an elegant and cool mork. A single black strip as a frame and a light grey mat give us a perfect atmosphere for this painting.

Fig. 174. Golden tonalities for the portrait you have just finished. It agrees with the general luminous quality of this painting, elegantly underlining the atmosphere created by the picture.

174

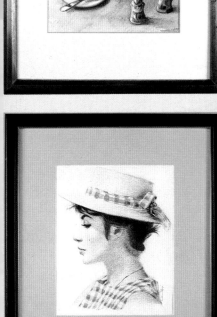

Fig. 175. A gilded frame with straight moldings and a white mat. They make a perfect combination with the rather cool quality of the watercolored still life. Yellow and gray is the general tonality, plus the red note at the base. The silver white of the frame fits like a glove.

175

Fig. 176. An elegant black frame with delicate molding and a golden edge. Light sepia for the mat. Isn't this the most suitable color for distinguishing the girl's profile and the general tonality?

176

Glossary

A

Airbrush. Instrument for drawing and painting, used mainly in illustration and graphic design. It consists essentially of a pistol loaded with liquid color and connected to an air compressor that "fires" the pulverized color at the support. It produces perfect flat stains and highly regular gradings. With the help of cut-outs, it is possible to paint specific shapes with total precision.

B

Binder. Materials used to blend and give cohesion to the coloring pigments that are used in the different drawing and painting media. These binders are what give the different techniques their character (oil, watercolor, pencil, pastel, wax), since the pigments are always the same.

C

Chromatic. Referring to color in general. "Chromatic toning" is equivalent to "toning the colors"; "chromatic quality" to "quality of the colors"; "good chromatism" means "good colors" or "good color."

Compose, composition. Placing or arranging the various elements of a painting (for example, a still life) in the most balanced and harmonious way possible. Or, if you are painting a landscape, "choosing" the area that contains the best conditions of harmony and equilibrium.

E

Execution. Execution in drawing and painting refers to the way or method of applying the brush, pencil, pastel sticks, or any other instrument to the support when the work is being done. This "way" may be delicate, nervous, brusque, slow, fast. It also refers to the fact of applying a larger or smaller quantity of pigment in techniques such as oil or acrylic painting. It particularly defines a painter's style.

F

Fauve. French word that can be translated as *wild beast.* It was given to the school that appeared at the beginning of the twentieth century and was characterized by the application of almost pure intense colors (reds, greens, and yellows) organized in compositions displaying strong, strident chromatic contrast. Vlaminck and Derain are artists who represent this tendency.

Fixative, liquid. Used in painting and drawing to prevent the dust of which some media are constituted (pencil, charcoal, Conté crayon, pastel, etc.) from coming off the support. It is sprayed on the works with aerosol-type pulverizers.

G

Grading. When a stain of color passes gradually from an intense to a soft tone (or vice versa), imperceptibly and with no abrupt jumps, it is a grading. Grading consists of painting or drawing this kind of stain.

Graphite pencil. The graphite pencil—also called lead pencil—is the ordinary everyday black pencil used not only for drawing but also for many other activities. It is so called because there is a greater or lesser amount of graphite in the composition of the lead (according to its degree of hardness) as an element that draws.

I

Impressionist school. A trend that appeared at the end of the nineteenth century in France, characterized by a pictorial concept based on scientific theories of color, capturing an instant of light and a less "finished" quality than that used by earlier schools. Monet, Manet, Renoir, Pissarro, and Degas are some of its most notable representatives.

L

Line drawing. A line drawing is done by means of lines with no stains or shadows. Only the outlines or contours that draw the essential forms of the models are marked out. It is not to be confused with *geometric* or technical drawing done with ruler, triangle and compasses.

M

Mat. A strip of paper, bristol board, cloth, etc., that is placed around a small picture or drawing when it has been framed. The *mat* is placed between the work and the frame and the color and width must be chosen carefully to give greater emphasis to the framed work.

Model. A word taken from sculpture. In drawing and painting it is applied to the action of *shadowing* (by means of the application of different tones) the various parts of the motifs to give an illusion of three dimensions on a support that has only two.

P

Pigment. The animal, vegetable, mineral, or chemical coloring material from which the colors used in every artistic medium are made. They come mixed with different binders (waxes, oils, gums, honey, etc.), and it is these that define the differences between some media and others, since the pigments themselves are always the same.

R

Range. Range (a word that comes from music) means the ordered succession of different tones of the same color. So, if you start from a soft blue and go through to an intense one (or vice versa) with various intermediary blues, we say that you have a range of blues. By extension, range is also used to refer to the quality of colors you have available at any given moment to paint a picture or to the group of colors that have been used in a painting or a drawing.

Reflected color. This is the color reflected or thrown by an object onto other nearby objects, tinging them with its own tonality. Capturing and expressing these reflected colors is decisively important in any picture to obtain a satisfactory representation of color.

S

Sable hair brush. This is the finest quality brush for painting and drawing with water techniques. It holds the load of water perfectly; the hair is tense but flexible and it always keeps an excellent point. It is made with the tail hairs of the kolinski, a small rodent that lives in the Soviet Union and China.

Sketch. The name given to a drawing or painting done in any medium used as a trial or preliminary for a later finished work. Sometimes the artist has to make many sketches until he manages to express in pictorial terms the idea he is pursuing.

Support. A support is the surface on which the drawing or painting is done, from a bristol board or a wooden board to a canvas or a wall, as in the case of murals.

T

Texture. The special tactile and visual quality of a surface. The word refers to the particular roughness, grain, harshness, softness, etc., of the various materials things are made from. In painting it is used to refer to the outstanding characteristics of the surface of a picture.

Tone. A musical term that when applied to color refers to the greater or lesser luminosity of a color in relation to black and white. A pale pink has a smaller or lower tone than an intense pink, for example.

V

Value, valuing. Value is the name given to the relation between two or more tones in the same picture from the point of view of its luminosity. When you compare the different tones of a work with each other and try to reach a good balance among them, you are valuing. The play of values was discovered and splendidly used by Baroque painters such as Vermeer or Velázquez.

W

Wash. The name given to a drawing done with a brush with Chinese (India) ink more or less diluted with water. The name is also used for a drawing done with one or two watercolors, usually black or sepia.

Well, my reader and friend, it is time to say goodbye. I know that you will never read the book again from cover to cover, but when you dip into it from time to time we shall be together again. We have walked together through a hundred pages, which is a lot if we think of it in terms of time. Most of all, we have worked. And we have connected, we have become friends, and we have reached a stage of intimacy with those slender pieces of cedar wood that are the colored pencils. It is the same with a man and a woman or with two good friends: they never become altogether intimate. There is always something to discover. And they discover it through contact.

In this case I would say . . . well, I'll say it and I assure you that you will discover it with practice. There is only one way along the road of art and that is practice. *You learn by doing.* It is the only way. Many writers and artists have said the same thing in different words: art is a tiny percentage of inspiration and a huge percentage of perspiration, of sweat, of work.

It's just that we, the people who devote our lives to art, are very privileged: our work satisfies us, it is an enormous source of pleasure that is practically unbeatable when things are going well, and what we are doing thrills and delights us. What luck!

Well, I'll leave you with your companions, the colored pencils. Don't abandon them. Spend some time with them every day: that will be enough for the friendship to blossom into something important.

Goodbye and good luck!

The author would like to thank the following persons and companies for their cooperation: José Luis Velasco for his help with the writing; Miquel Ferrón for the subjects published on pages 63, 73, 95, and 105; Vicente Pera; the Prisma company for the layout; and the pencil manufacturers Caran D'Ache, Rexel Cumberland, and Faber-Castell.